IMAGES
of America

KEARNEY'S WORLD THEATRE

SHAWN,
I HOPE YOU LIKE
THE BOOK!

KEITH TERRY
JUNE 14, 2011

IMAGES
of America

KEARNEY'S
WORLD THEATRE

Keith Terry

Foreword by World Theatre Foundation president Jon Bokenkamp

ARCADIA
PUBLISHING

Published by Arcadia Publishing
Charleston, South Carolina

Printed in the United States of America

Library of Congress Control Number: 2010931804

For all general information, please contact Arcadia Publishing:
Telephone 843-853-2070
Fax 843-853-0044
E-mail sales@arcadiapublishing.com
For customer service and orders:
Toll-Free 1-888-313-2665

Visit us on the Internet at www.arcadiapublishing.com

This book is dedicated to Lisa Terry, Darrell and Corinne Terry, and Frank and Dorothy Nuckolls.

CONTENTS

ACKNOWLEDGMENTS

This history of the World Theatre is available to readers because many generous and helpful people made themselves or their photographs, scrapbooks, or other resources available to this writer. Many contributors, having never met the author, used the US Postal Service to send him cherished World-related memorabilia and trusted that they would be returned as promised. Others allowed this stranger to visit them in their homes so that he could make digital scans of photographs, brochures, and booklets. This project would not exist without the help of all of the contributors. The author called on a small group of people numerous times because they had insights or connections and they happily responded on each occasion. These people deserve special recognition: Kaye Linn Albrecht, Jon Bokenkamp, Jennifer Murrish, and Jackie Schutt. These institutions provided resources or lent assistance that was invaluable: the American Theatre Organ Society; the Boys Town Hall of History, Omaha; the Buffalo County Historical Society, Kearney, Nebraska; the Douglas County Historical Society, Omaha; the High Plains Historical Society, McCook, Nebraska; the Theatre Historical Society of America, Elmhurst, Illinois; the University of Nebraska at Kearney; the Warsaw Historical Society, Warsaw, New York; and the World Theatre Foundation, Kearney, Nebraska.

FOREWORD

A movie theater is a funny thing. As you look back, you can measure time by the movies you remember seeing in a specific theater—first dates, midnight movies, or matinees with your kids. For me, The World Theatre is like a timeline of my love affair with movies because, like most kids in Central Nebraska, I received my education in film at the corner of Twenty-fourth Street and Central Avenue.

Before VHS, before satellite, before the Internet and the iPad, there was The World. That dinosaur gave us everything from *Casablanca* to *Breakin' 2: Electric Boogaloo*, and in the process it has watched us grow up. It is where Ward Schrack worked as an usher for 50¢ an hour. It is where DeLoss Wilke performed lived on stage with his Brahman bull, Bomber. And it is where, in 1943, John Gerber helped his daddy sell $14,000 worth of 5 and 10¢ popcorn. The point is, if you are holding this book, chances are you have got a memory of the World Theatre.

The screen officially went dark in 2008, and shortly thereafter I reconnected with one of my favorite professors from the University of Nebraska at Kearney, Dr. Keith Terry. I told Keith about my passion for the theater and how I hoped to see it reopened, and Keith told me about his passion for history. Little did I know, he had taken to writing books. His first two books were well received, and he was considering a third. As for a subject, Keith wanted to focus on a forgotten piece of history. When he suggested The World as a subject, I jumped at the opportunity to help.

The truth is, I had been researching the World Theatre for over a year without much luck. What I was searching for were photographs that would convey the spirit of the place; not images of the building itself, but snapshots that gave a sense of the community atmosphere the theater was built upon. In over one year, I found a total of six uninspired images.

Keith said there were more.

He said these snapshots were hiding in shoeboxes and dresser drawers, in the family albums of people who did not know what they had in their possession. I told Keith he was nuts. He told me he needed a little time to write a few letters.

Two years later, after countless e-mails, interviews, and letters, Keith delivered his manuscript. Somehow he managed to unearth over 180 wonderful photographs along with stories that brought the theater back to life. The result is a detailed history documenting Kearney's love affair with its last original movie theater.

Remarkably, Keith's research has influenced the future of The World in ways he never intended. The photographs and stories he unearthed have been used as the foundation for a historically accurate renovation; pieces of the past that were uncovered during his research have been carefully worked into the renovation plans wherever possible.

So if you love movies, or history, or this wonderful strip of road called "The Bricks," you are in for a treat. I hope you find this book both entertaining and informative, and I hope you will stop by the newly renovated World Theatre to make new memories. After all, it is a living, breathing piece of history—and it belongs to you.

Thank you for purchasing this book. And thank you, Keith, for your inspired work. It means the World.

—Jon Bokenkamp
President/Founder,
The World Theatre Foundation

INTRODUCTION

The World Theatre was much more than a movie house; it was a place where one was exposed to things exciting, discomforting, or even a world away. It was where people learned the most current news pertaining to national politics, far-off wars, major-league sports, and the glitz of Hollywood. On the stage, musicians and performers entertained, teachers provided instruction, and speakers offered words to motivate and congratulate. It was where first loves blossomed and faded; where a kid could be entertained for a few hours and a parent would know he or she was safe; where one could escape from reality to enjoy another time, setting, or community; and where proven and potential stars performed for a local audience and received immediate and honest feedback.

The films there were initially silent and featured stars who are now almost completely forgotten though immensely popular in their day. These include Lilyan Tashman, Gene Pallette, John Gilbert, Renee Adoree, Delores Del Rio, Victor McLaglen, and others. Later, sound-on-film was developed, color was introduced, and a new generation of performers entertained audiences. Examples include the Marx Brothers, W.C. Fields, George Burns, Gracie Allen, Bela Lugosi, Vivien Leigh, and Clark Gable. Many still remember these luminaries, but in time, memories of them will fade away, too. The same will eventually happen to those who grace the screen today, but the theater itself will remain the constant in the midst of the rising and falling tides of humanity that will pass through it.

Built in 1927, the World outlasted other Kearney institutions that showed movies or hosted stage acts such as the Airdome, the Crescent, the Empress, the Isis, and the Lyric. It no doubt survived partly because its genesis was brought about by the Masons, a group with a long history and a stable leadership in Kearney. When the Masons' temple at Twenty-fourth Street and Central Avenue was developed, it was purposely built to include a theater to serve as a revenue stream to help the group pay for the entire building. However, it was a symbiotic relationship; the Masons needed the World to thrive financially, and the theater benefitted by having a prime downtown location and being under the roof of a firmly rooted organization.

A number of men served as managers at the facility, with some filling the role for several years while others were there for only brief periods. G.E. Dyson (1927–1928) was hired first, and he was followed by W.H. Bergmann (1929–1930), Eddie L. Forrester (1930–1931), Rowan Miller (1931–1932), Eddie L. Forrester (1933), Carl P. Rose (1933), R.R. Blank (1933), O.V. Goodman (1933–1934), Nevins R. Lynn (1937–1939), Maynard A. Nelson (1939–1942), Joseph L. Cole (1947–1952), Ed Schoenthal (1953), Clinton Smestad (1953–1965), Raymond Langfit (1967–1973), and Richard L. Smith (1973–2008). This information came primarily from Polk's Business Directories for the city and digitized copies of the *Kearney Hub* available through the Kearney Public Library. The Polk's directories were not always accurate since the World's listing in the directory may have been sent to press several months before the publication actually was available, and during that time, a personnel change may have occurred at the movie house. As a result, the data from Polk's were compared against information from other sources. A complete set of directories covering all of the early years of the theater was not available.

Researching the history, people, and events at the World was done primarily by using stories from the *Kearney Hub* newspaper. Interviews were conducted by the author with former employees, patrons, and entertainers, and from these narratives were written. The *Antelope*, the student newspaper at the University of Nebraska at Kearney, was also a useful resource for some events and information. Some primary documents, such as the Masons' articles of incorporation and original blueprints, were used, among others.

One

THE NEW WORLD

The World Theatre exists today because of the vision and strategic thinking of the fathers of the current Masonic organization in the city. Without them, their long-range plan, and their investments, the World would have probably gone the way of other Kearney theaters that existed at one time, such as the Airdome, the Crescent, the Empress, the Isis, and the Lyric. Once work was begun on the Masonic Temple, which now is home to the movie house, it was really the product of Kearney money, labor, and materials. When it opened, it was with great publicity and fanfare attracting thousands from a sparsely populated area, suggesting that residents were excited to experience the films, newsreels, and vaudeville acts that were scheduled. They were probably also curious about what the place looked like inside, considering that so much had been written about its development and accoutrements in the local paper.

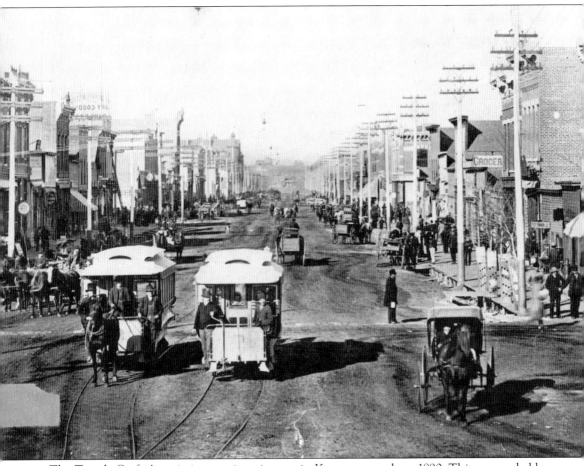

The Temple Craft Association was in existence in Kearney as early as 1890. This was probably an umbrella organization for several Masonic societies, including Robert Morris Lodge No. 46, Ancient Free and Accepted Masons; Kearney Chapter No. 23, Royal Arch Masons; Mt. Hebron Commandery No. 23, Knights Templar; Damascus Lodge Perfection No. 7, Ancient and Accepted Scottish Rite; and Tuscan Lodge No. 35, Order of the Eastern Star. The February 1, 1890, *Kearney Hub* indicated that the group owned the lot at the corner of Twenty-fourth Street and Central Avenue, which would eventually become the site of the present Masonic Temple and the World Theatre. There was speculation that they might break ground that year, but they chose not to and, instead, issued more capital stock, according to the July 7, 1890, edition of the newspaper. This may have been to generate more cash for building at a later date. This photograph of Kearney's Central Avenue is from the same period in which the Masons were seeking investors for their construction endeavor. (Courtesy of the Buffalo County Historical Society.)

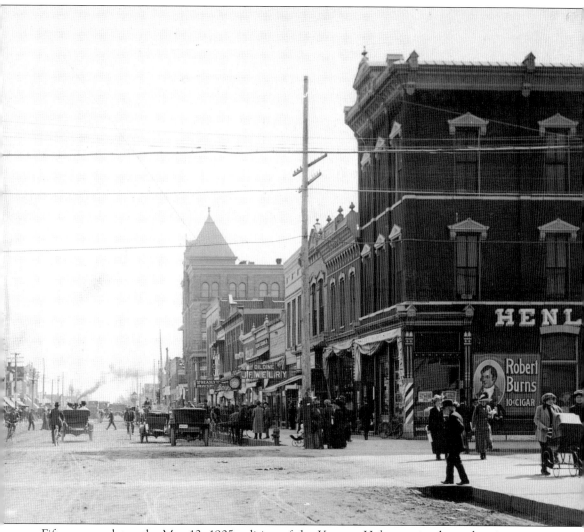

Fifteen years later, the May 12, 1905, edition of the *Kearney Hub* contained an advertisement showing the Henline Building at 2122 Central Avenue. Stephen A. D. Henline, a Mason having achieved the degree of Knight Templar in that order, maintained a drugstore on the first level. He shared the floor with the Western Union Telegraph office and a dentist. Other businesses there included the Kearney Telephone Company, three attorneys, and a real estate agent. At the time, the Masonic Temple was on the third floor, and it appears that the group was leasing the space. Within seven years, they had purchased a second lot at the corner of Twenty-third Street and Central Avenue and were preparing to build. According to the *Kearney Hub* on August 31, 1912, the Masons were ready to contract with Richard Hibberd and W.F. Crossley to carry out the construction project. The Henline Building, shown here on the right, still exists and is on the southwest corner of Twenty-second Street and Central Avenue. (Courtesy of the Buffalo County Historical Society.)

F.J. Switz, H.A. Webbert, W.W. Barney, J.G. Lowe, and W.S. Clapp formed a corporation to establish the Masonic Temple Association of Kearney on September 1, 1912. The goals in their Articles of Incorporation state, "The business to be transacted by said corporation shall be the erection and maintenance of a building for the use of the Masonic Lodges in said city . . . to use or rent for other purposes such portions thereof as may not be needed or wanted . . . and to own and hold the necessary real estate as a site therefor." Their clear intent was to develop partnerships with entities that would share their space to defray operating costs and build equity. J.G. Lowe is pictured at left, and below is W.W. Barney. (At left, courtesy of the Lowe family; below, Nancy Barney.)

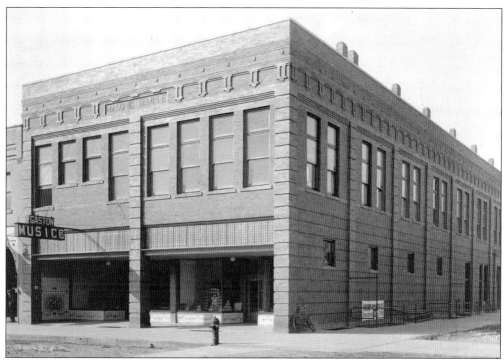

The site for the first temple to be owned by the organization was at 2224 Central Avenue. Based on *Kearney Hub* accounts, work began in September 1912, and by mid-October steel girders for the second floor were in place. The Masons' structure was situated alongside another owned and being built by Richard Hibberd of the Hibberd Brick Company. News was announced Christmas Day 1912 that the Gaston Music Company had signed a five-year lease with the fraternal organization to use the ground floor and basement of their building to display and demonstrate musical instruments. In 1964, Gaston's became the first Kearney location for Yanda's Music. The marble nameplate containing the words "Masonic Temple" still adorns the front of the building. Below is the Hibberd Brick Company production facility. (Courtesy of the Buffalo County Historical Society.)

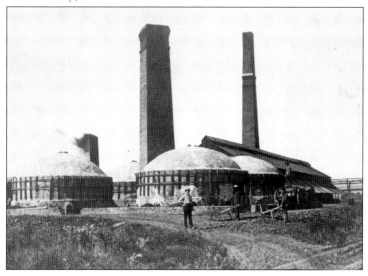

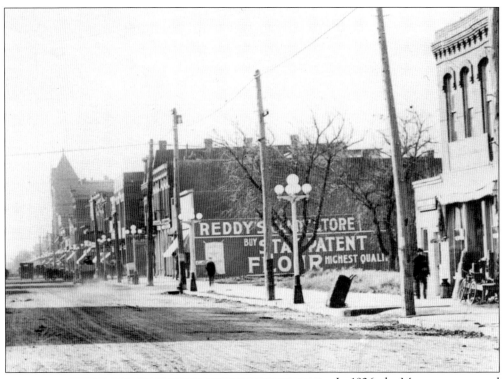

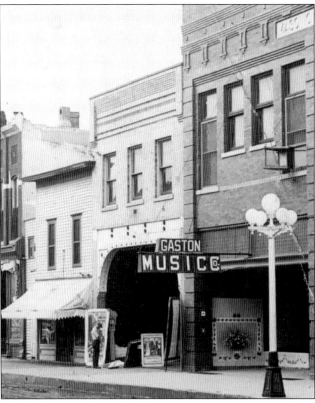

In 1926, the Masons announced plans to construct again but this time at Twenty-fourth Street and Central Avenue on the site they had purchased in 1890. Above is Reddy's Candy Store before 1915 at the location where the World was erected. Newspaper ads indicated that they sold Coca-Cola as well as fudge, caramels, and mints. Malted milk cost 10¢, and two ice cream cones were a nickel. Later, it was operated as Morrow's, where sweets, pipes, cigarettes, and tobacco were sold. At left is one of the established movie houses at the time, the Crescent, with the arched doorway, which opened its doors September 14, 1907. Kearney Cycling & Fitness is now in the same location. (Above, courtesy of the *Kearney Hub*; at left, the Buffalo County Historical Society.)

The group hired architect James T. Allan of Omaha, who had developed structures in Des Moines, Salt Lake City, and Pocatello. In Omaha, he had produced plans for the Greyhound Bus Depot, the Roseland Theatre, the Wachob-Bender Corporation, the Merchants Biscuit Company, the Omaha Municipal Airport Terminal, and the Ambassador Apartments. The cost of construction for the new temple was $110,000, but additional work such as wiring, plumbing, and heating would push the total to approximately $160,000. The *Kearney Hub* reported on September 21, 1926, that Allan had been in Kearney the day before to meet with the parties involved. Pictured is James T. Allan. (At right, courtesy of Lois Allan Waller and Jean Allan Willis; below, the Masonic Temple Association, Kearney.)

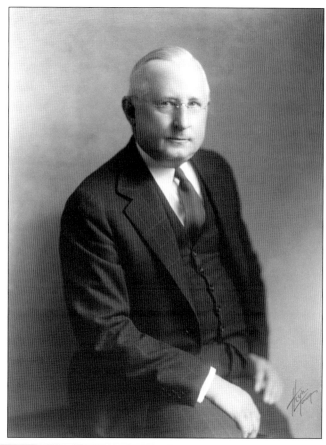

MASONIC TEMPLE & THEATRE BUILDING

KEARNEY NEBRASKA

JAS. T. ALLAN ARCHITECT

OMAHA NEBRASKA

SHEET NO

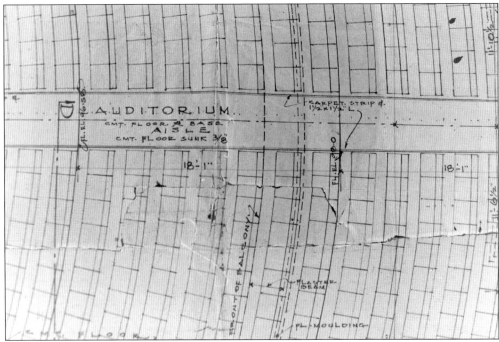

From the beginning, the new building was intended to have a theater on the ground floor. This was in holding with the strategy the Kearney Masons had adopted years earlier of providing space in their facilities to other businesses to generate income. Allan's blueprints indicate that there was to be a single auditorium with seating for 1,100, a balcony, a lobby and ticket booth, an orchestra pit, organ space, dressing rooms, and a projection room. The World Realty Company of Omaha, which was already operating movie houses in Omaha, Fremont, Columbus, Grand Island, and McCook, leased the theater space from the Masons before building even commenced, according to the *Kearney Hub* on September 21, 1926. (Courtesy of the Masonic Temple Association, Kearney.)

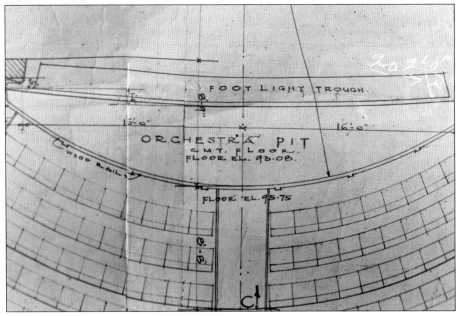

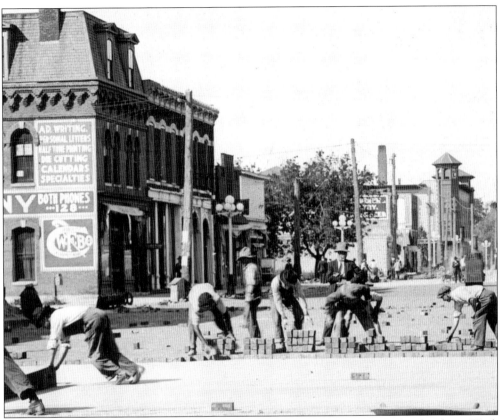

Clearing of the lot began about September 23, 1926, and excavation began a few days later. Work progressed steadily over the next several months, and passersby reported they could see that the dressing rooms, orchestra pit, and stage were discernible among the steel beams and concrete foundations. Then, in June 1927, the City National Bank advertised six-percent Masonic Temple bonds in the *Kearney Hub*. Apparently, the Masons needed to raise capital for work to continue, so $125,000 in bonds were issued with the hope that Kearney citizens would invest in the project. The image above shows another view of the structure that was probably on the lot before construction began. It is in the center with the white upper facade beyond the bricklayers. (Above, courtesy of the *Kearney Hub*; below, the Masonic Temple Association, Kearney.)

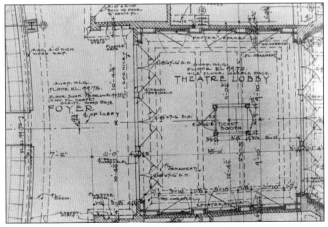

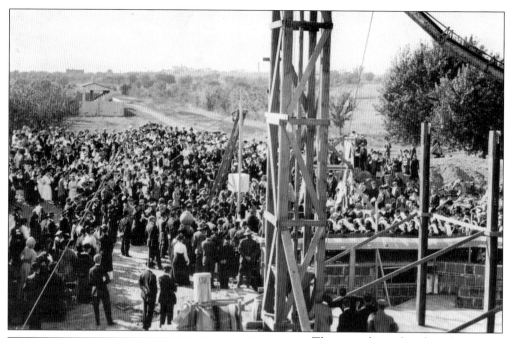

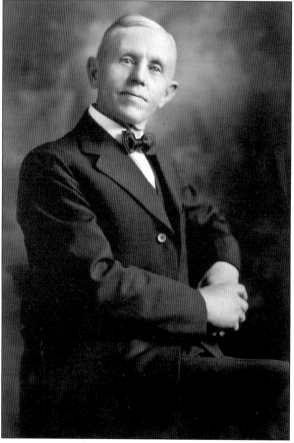

The man charged with making Allan's vision a reality was Henry Knutzen of the Walter Knutzen & Son Construction Company of Kearney. Walter died in 1919, but the company the two developed was prolific, having been awarded many significant contracts in Colorado and Nebraska. Locally, their contracting work included the present-day Kearney City Hall, many city schools including Kenwood Elementary, and St. Luke's Episcopal Church. On the University of Nebraska at Kearney campus, Knutzen crews built Old Main, the first administration building, much of the State Tuberculosis Hospital, A.O. Thomas Hall, Copeland Hall, and Men's Hall. Above, the cornerstone is being positioned for Old Main. Walter Knutzen, the founder of the company, is shown at left. (Above, courtesy of the University of Nebraska at Kearney; at left, the family of Henry A. and Lenore M. Knutzen.)

News was announced in the July 23, 1927, *Kearney Hub* that C.L. Gaston of Gaston's Music agreed to buy the building the Masons were to vacate at 2224 Central Avenue for $30,000. Many in Kearney came forward to buy the notes that were available for the Masonic Temple in denominations of $100 to $1,000. These were 30-year certificates that paid six percent interest and could be redeemed after 50 years. On August 5, 1927, the *Kearney Hub* stated that 25 firms and individuals had purchased bonds for the project, with the three largest being bought by the American State Bank, Henry Knutzen, and the World Realty Company. Crews returned to work immediately. Below is the interior of the Empress and the standard that needed to be achieved. (Above, courtesy of the *Kearney Hub*; below, the Buffalo County Historical Society.)

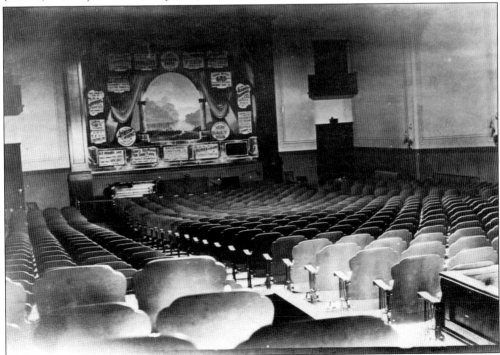

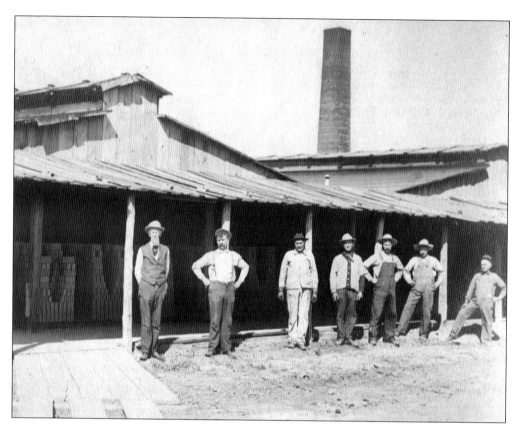

The building was to be 130 by 75 feet and virtually fireproof with metal windows, a concrete auditorium floor, and stone accoutrements. The construction work was done primarily by Kearney companies and probably included the Hibberd Brick Company, which operated where present-day Kearney Catholic High School resides. During his career, Richard Hibberd and his crews made tens of thousands of bricks for regional and local buildings, including numerous churches and schools, including the University of Nebraska at Kearney as well as the Youth Rehabilitation and Treatment Center. It is quite likely that their product graces the exterior of the World. Above, Richard Hibberd is shown at the extreme left at his place of business. (Above, courtesy of the Buffalo County Historical Society; below, the University of Nebraska at Kearney.)

By October 22, 1927, Henry Knutzen's men were finishing the theater, installing the canopy over the entrance, and completing the ornamental plaster ceiling. The mahogany and glass front doors had been hung, tile had been laid in the lobby, and spindle railing had been installed around the orchestra pit. The cement floors in the auditorium were finished but lacked aisle carpeting. The theater seats had arrived by train and were to be fitted once the painters finished. In the temple, workmen were putting down the terrazzo, sanding the ballroom floor, and hanging lamps like the one seen in architect Allan's blueprints. Henry Knutzen and Lenore Martin, shown above, were wed a short time before he started on the World. (Above, courtesy of the family of Henry A. and Lenore M. Knutzen; at right, the Masonic Temple Association, Kearney.)

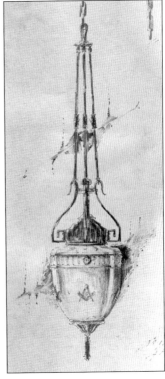

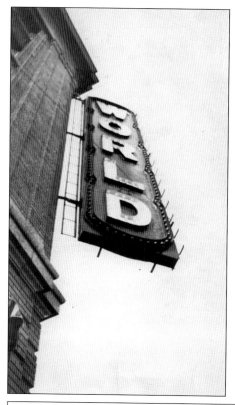

The sign that hung vertically on the corner of the building was meant to serve as an inviting beacon and attention-getter for those who might be in sight of it. It was 24 feet long and four feet wide with letters three feet high. On each side, it had a running circle of 300 red and white bulbs that appeared to chase one another around its borders, and 400 more were mounted within the letters. The marquee above the doors to the World was also dramatic and served to make the entryway look impressive and cheery. On the underside of it were six globes containing 1,000-watt lights along with 100 additional smaller bulbs. Behind the lettering announcing the attraction of the day were more lights. (At left, courtesy of the Buffalo County Historical Society; below, the Masonic Temple Association, Kearney.)

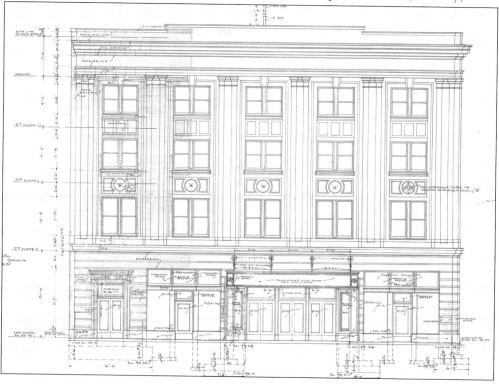

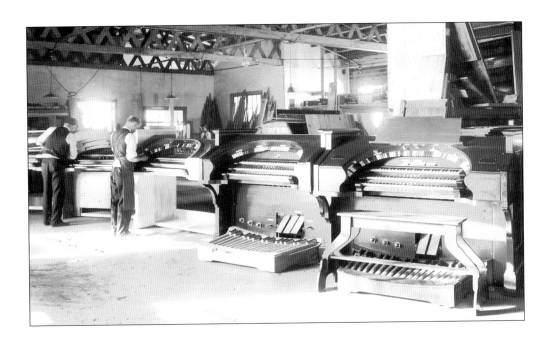

Entertainment at the theater would initially consist of silent movies, vaudeville acts, and other stage performances. Vital to all of these was a source of music as accompaniment, and for just that reason, executives of the World Realty Company purchased an impressive Marr & Colton organ. This two-keyboard instrument could simulate the sounds of the violin, trumpet, trombone, saxophone, and drums. According to the October 17, 1927, *Kearney Hub*, the instrument had arrived two days before, probably by train. Seen here in the early 1900s, workers are assembling Marr & Colton instruments at the factory in Warsaw, New York. (Above, courtesy of the Warsaw Historical Society, Warsaw, New York; below, John Hubert, High Plains Museum, McCook, Nebraska.)

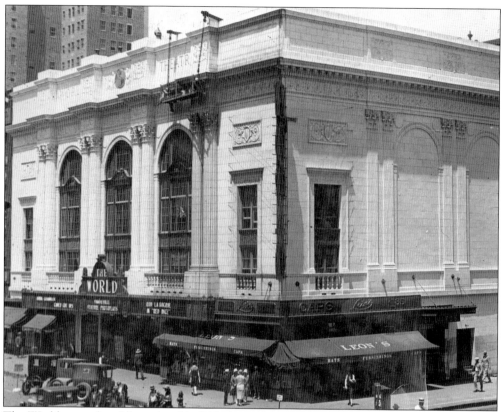

The World opened on November 14, 1927. At 6:30 p.m., people rushed in, filling the 1,100 seats while many stood during the two-hour program. Hundreds more waited for the second show in the lobby and outdoors. Representatives from the Masons, Kearney's mayor, and architect James T. Allan spoke. Arthur Hays from the World Theatre in Omaha entertained on "the World Wonder Organ," a vaudeville troupe performed, and the film *Adam and Evil* was shown with an *Our Gang* comedy. Opening-night tickets were 50¢ for adults and 25¢ for children. Shown above is the World in Omaha around 1926 when Hays was the featured artist there. Below is a finished organ at the Marr & Colton factory. (Above, courtesy of the Applebee-Beasley ancestry files, Beatrice, Nebraska by Dr. Carol Fuller; below, the Warsaw Historical Society, Warsaw, New York.)

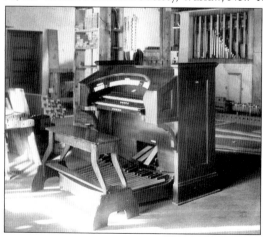

Two

THE WORLD'S HEYDAY

Once the doors opened, the World quickly established itself as an integral part of the framework of the community. The question then is, "Why was the theater so important?" In the early- to mid-1900s, radio broadcasting was relatively new; few AM stations existed in the Midwest, programming was available only a couple of hours a day in many places, and radio receivers were expensive. Furthermore, television was not commercially available on a widespread basis either because it was still not perfected. Also, its development was halted during World War II because of the need to save precious metals used to build TV equipment. Because there were few other news or entertainment options highlighting the national or international scenes besides newspapers, it was not uncommon for some Kearney residents to go to the theater every week.

The World Theatre was also the newest of those in town and was believed by many to be the "classiest" because of its interior architectural elements, cleanliness, comfort, and entertainment. Effective air-conditioning was not affordable for most homeowners early in the 20th century, so escaping to the World, which had an effective cooling system, for a few hours of leisure on a hot summer day or evening must have been refreshing. Many believed the best and newest movies or those with the biggest stars ended up being shown there and that the other houses in town received second-tier productions.

For a few coins, a person bought amusement, diversion, and enlightenment at the World. One got to see a stage presentation by a vaudeville troupe, a musical performance, or an animal act. A newsreel might have followed this, with the latest in politics, crime, current affairs, and sports. A cartoon or short comedy was often part of the mix and led up to the marquee feature.

Before there was so much competition for ears and eyes, theaters were magnificently regal—and the World was Kearney's king.

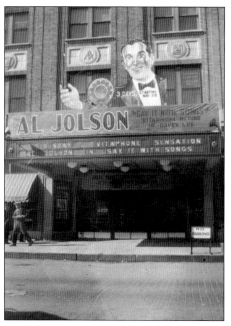

Al Jolson, Hollywood's highest paid star in the early 1900s, appeared in *Say It with Songs* at the World in November 1929. He was featured in the *Jazz Singer* in 1927 and the *Singing Fool* in 1928. These three talkies used Warner Brothers' Vitaphone technology. In theory, the film began and started a record player holding a disk containing the entire movie sound track, but there were occasionally problems with the audio not being in sync with the actions of the on-screen talent. Developments such as Vitaphone almost instantly led to the decline in popularity of silent movies as well as the careers of many in-house theater musicians. Pictured below is one of the competing Kearney movie houses, the Crescent, beside the Gaston Music Company. (At left, courtesy of the Buffalo County Historical Society; below, Sherry Morrow.)

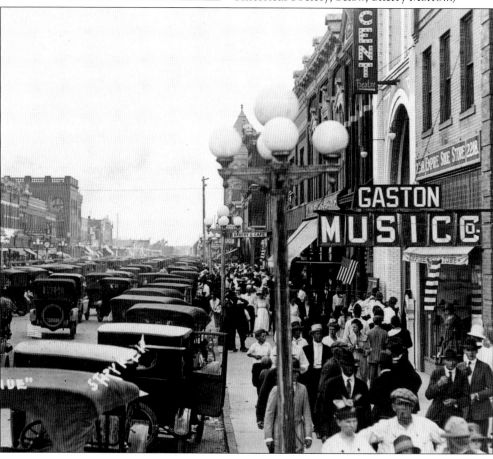

Warner Brothers' Vitaphone was available at the same time Fox studio technicians were perfecting Movietone, a synchronized sound-on-film approach. Many theater owners upgraded their sound and projection systems when new technologies were introduced if they wanted to continue selling tickets. Between 1927 and 1929, theater managers were caught between these competing technologies and were forced to choose one of the two or, if financially possible, install both. By 1929, the cost to purchase Movietone theater equipment, the eventual winner in the technological battle, was between $5,000 and $7,000. This was a significant sum for places like the World, and each new development that followed, some short lived, created even more financial burdens for these operations. Below are Allan's architectural blueprints for the balcony and projection booth. (At right, courtesy of Russ Erpelding; below, the Masonic Temple Association, Kearney.)

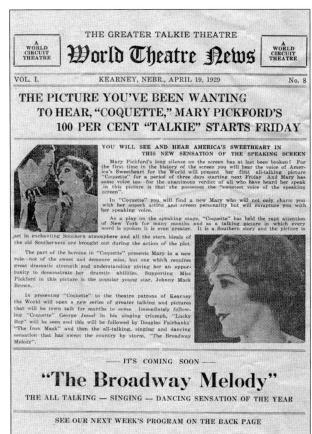

THE GREATER TALKIE THEATRE

A WORLD CIRCUIT THEATRE

World Theatre News

A WORLD CIRCUIT THEATRE

VOL. I. KEARNEY, NEBR., APRIL 19, 1929 No. 8

THE PICTURE YOU'VE BEEN WANTING TO HEAR, "COQUETTE," MARY PICKFORD'S 100 PER CENT "TALKIE" STARTS FRIDAY

YOU WILL SEE AND HEAR AMERICA'S SWEETHEART IN THIS NEW SENSATION OF THE SPEAKING SCREEN

Mary Pickford's long silence on the screen has at last been broken! For the first time in the history of the screen you will hear the voice of America's Sweetheart for the World will present her first all-talking picture "Coquette" for a period of three days starting next Friday And Mary has some voice too—for the unanimous verdict of all who have heard her speak in this picture is that she possesses the "sweetest voice of the speaking screen".

In "Coquette" you will find a new Mary who will not only charm you with her superb acting and screen personality but will enrapture you with her speaking voice.

As a play on the speaking stage, "Coquette" has held the rapt attention of New York for many months and as a talking picture in which every word is spoken it is even greater. It is a Southern story and the picture is set in enchanting Southern atmosphere and all the stern ideals of the old Southerners are brought out during the action of the plot.

The part of the heroine in "Coquette" presents Mary in a new role—not of the sweet and demure miss, but one which requires great dramatic strength and understanding giving her an opportunity to demonstrate her dramtic abilities. Supporting Miss Pickford in this picture is the popular young star, Johnny Mack Brown.

In presenting "Coquette" to the theatre patrons of Kearney the World will open a new series of greater talking and pictures that will be town talk for months to come. Immediately following "Coquette" George Jessel in his singing triumph, "Lucky Boy" will be seen and this will be followed by Douglas Fairbanks' "The Iron Mask" and then the all-talking, singing and dancing sensation that has swept the country by storm, "The Broadway Melody".

— IT'S COMING SOON —

"The Broadway Melody"

THE ALL TALKING — SINGING — DANCING SENSATION OF THE YEAR

SEE OUR NEXT WEEK'S PROGRAM ON THE BACK PAGE

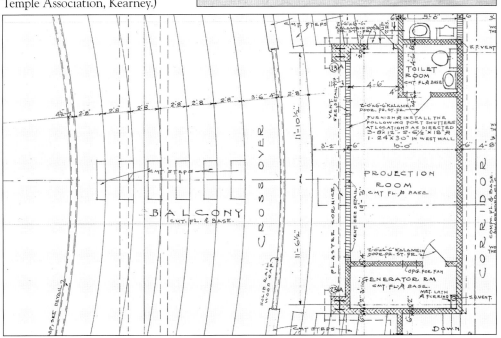

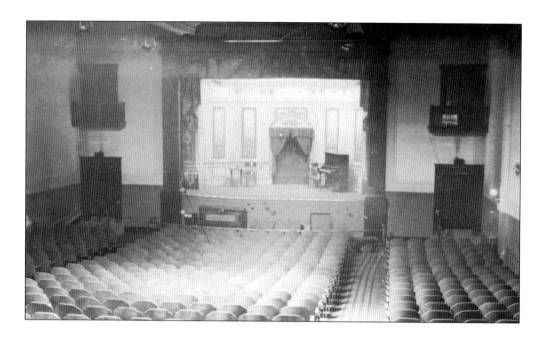

Less than two years after opening, I.B. Zimman of the World Realty Company in Omaha confirmed in the September 23, 1929, *Kearney Hub* that the World in Kearney had been sold to Publix Theatres of New York City. Twelve days later, the Empress, which later became the Fort, and the Crescent movie houses in Kearney also were sold to Publix by their owner, Universal Theatres. The World closed briefly in November for remodeling and to install Western Electric talking picture equipment. Afterwards, the Empress, whose interior is shown above, underwent similar work. After both reopened, the World was the primary theatrical venue open every day, and the Empress operated on weekends only. The Crescent, seen below just beyond the Gaston Music sign, was closed permanently by November 16, 1929. (Courtesy of the Buffalo County Historical Society.)

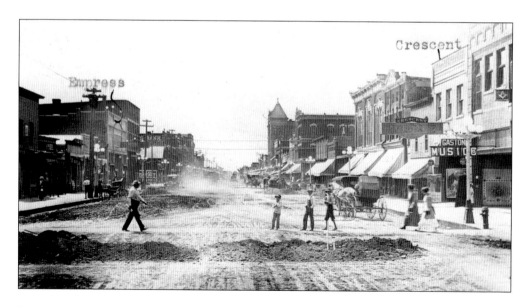

Professional vaudeville acts were very popular at the World immediately after its opening, and three or four were usually scheduled the same night as a movie. The genre included entertainers such as musicians, comedians, thespians, acrobats, animal trainers, and magicians, and at the World, it appears the more variety among appearing vaudevillians, the better. On one night at the theater on April 21, 1928, Singer's Midgets Jazz Band played, including "ten little men and women of mirth and melody," Swor & Swor performed *Down Wonder*, and Fred Welle, "the Wizard of the Air," entertained the crowd; the movie was *Monkey Talks* with Olive Borden. On another night, it was the Sub-Debs Revue, Happy McNally, "the Human Locomotive," Frank & Vera Varden, "Those International Entertainers," and Jim and Flo Bogard in *Harmony and Laughs*. The film shown was the *Apache*. (Courtesy of Fort Theatre Dentistry.)

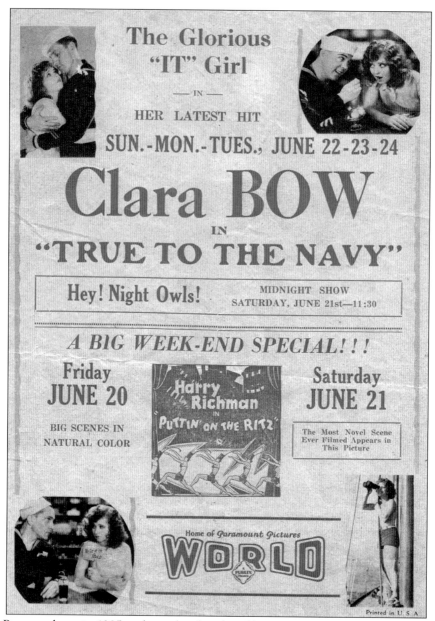

The Glorious
"IT" Girl
— IN —
HER LATEST HIT
SUN.-MON.-TUES., JUNE 22-23-24

Clara BOW
IN
"TRUE TO THE NAVY"

Hey! Night Owls! MIDNIGHT SHOW
SATURDAY, JUNE 21st—11:30

A BIG WEEK-END SPECIAL!!!

Friday
JUNE 20

BIG SCENES IN
NATURAL COLOR

Harry Richman
IN
PUTTIN' ON THE RITZ

Saturday
JUNE 21

The Most Novel Scene
Ever Filmed Appears in
This Picture

Home of Paramount Pictures
WORLD

Printed in U.S.A.

Clara Bow was born in 1905 and acted in her first film in 1922. She was extremely popular among silent moviegoers because she came off as expressive and humorous, and she was especially admired and desired by men. These attitudes may have been bolstered by tabloid stories of her supposed affairs with a number of Hollywood's most popular leading actors. Bow was considered the country's leading *it* girl because of her work in a 1927 romantic comedy of the same name in which she, a shop girl, wins the heart of the owner of the department store where she works. The reference to her as an *it* girl from that point on was also a subtle and polite way of saying she was a sex symbol without actually using what was considered at the time to be coarse language. *True to the Navy*, with the era's premier flapper, was heavily promoted in the pages of the *Kearney Hub* in June 1930. This all-talking film featured "the reckless, ravishing redhead" Clara Bow. (Courtesy of Marty and Karen Childs.)

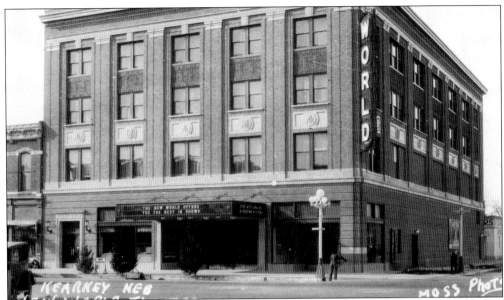

The World had established itself as a vital institution in the community, and as evidence, manager Eddie Forrester was asked to speak at the 1931 men's spring semester convocation at Nebraska State Teachers College at Kearney, according to the January 16 edition of the student newspaper, the *Antelope*. He discussed the future of movies and developments he thought patrons could expect in their lifetimes. These were the creation of three-dimensional films, rear projection where the image is cast from behind the screen, and a technique where relevant aromas or odors would accompany scenes. At right is James T. Allan's design for exterior lamps, which are visible in the image above on either side of the Masonic Temple doorway left of the theater marquee. They still hang there today. (Above, courtesy of Sherry Morrow; at right, the Masonic Temple Association, Kearney.)

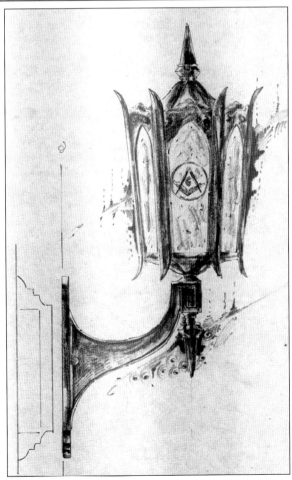

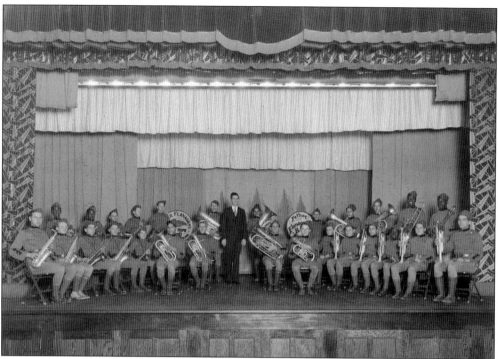

For two nights in September 1931, a group of 25 young men appeared at the World and entertained audiences under the direction of Fr. Edward Joseph Flanagan. Ten years earlier, he had established a village for young homeless males in Omaha and named it Boys Town. Flanagan provided abandoned and homeless boys with an education, taught them a trade, and if so inclined gave them instruction in the arts. The group at the World played classical and orchestral tunes, the "Bradley Brothers crooned old time songs," and the Gloom Chasers, a saxophone sextet, presented "a merry mélange of melody," according to the September 3, 1931, *Kearney Hub.* The image above was taken in 1932 at another location but probably includes some of the same who appeared in Kearney the year before. (Above, courtesy of the Boys Town Hall of History Collection; below, the Buffalo County Historical Society.)

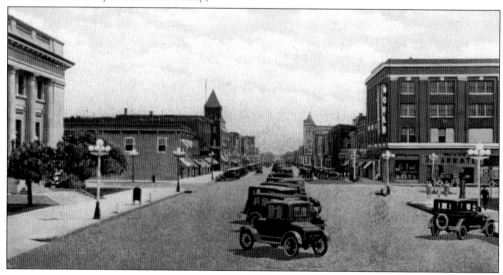

In addition to being a movie house and a venue for live performances, the World Theatre was also a perfect place to see the newest fashions. Starting soon after the theater opened its doors, and for at least the next 20 years, the stage was used by local clothing merchants to exhibit formal wear, casual wear, and accessories to a captive audience. On September 4, 1931, the *Kearney Hub* carried an advertisement for the Sylvia Richter Gown & Hat Shoppe, which presented at the theater the fall lines for misses' and women's "suits, coats, dresses and millinery . . . and displayed by living models in the 1931 manner." In 1932, there was a bathing suit and pajama review featuring "8 beautiful models," and two years later, there was another sponsored by Ruter's the Fashion. (Courtesy of Russ Erpelding.)

In preparation for destructive Halloween-evening antics that had apparently plagued Kearney in previous years, World Theatre manager Rowan Miller teamed up with the *Kearney Hub* and other merchants to provide two hours of entertainment for local youth in 1931. The entry fee was a signed statement presented at the box office that read, "To Frank Tracy, Chief of Police–I hereby pledge my support in protecting our city on Hallowe'en. I will not move or damage any property and will use my influence toward keeping others from doing so." In addition to a Jack Oakie and Eugene Pallette Western and a comedy starring Chester Conklin, there were kid-competitions between flicks. Young people arrived two hours before the doors opened, and at 9:45 a.m. more than 1,100 of them rushed into the theater in search of the best seats. Those filled immediately, leaving others to sit on laps and in the aisles. Sunlight Bakery and the Keenan Candy Company offered free cookies and other confections. Seen here is Chief Tracy in uniform at the World on the same day. (Courtesy of the Buffalo County Historical Society.)

The advertising copy for *Rebecca of Sunny Brook Farm* in the July 22, 1932, *Kearney Hub* indicated that the movie was as "refreshing as our cooling plant," which was enticing on sweltering days and sultry nights. The image at right shows the World's blower, approximately seven feet in height, used to move chilled air through the facility. The rest of the operation included a heavy-duty electric motor, a fan belt connecting the motor to the blower, a massive radiator positioned in front of the blower, and below, the fan's speed control. The system was simple but effective. Water was pumped from an underground well into the radiator, and the blower was actuated and pulled air through the radiator. This cooled air left the blower and was directed upwards into the building's ductwork. (Courtesy of the World Theatre Foundation.)

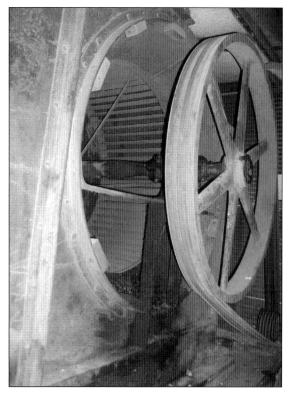

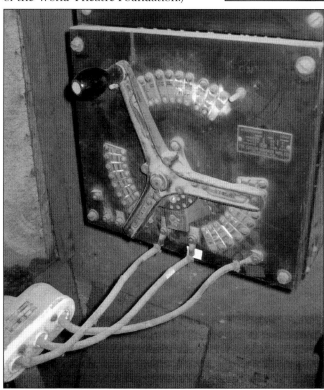

THE WORLD THEATRE

"Every Patron An Honored Guest"

W. H. BERGMANN, Manager.

STAFF

P. M. PETERSON, Ass't Manager
FRANK KRETZER, Projectionist.
REVA GIBSON, Cashier.
STERLING GRABIN, Organist.
W. G. OVERHOLT, Artist.
J. WELTON, Doorman.
ERMA GRISS, Head Usher.
W. N. PETERSON, Stage Mgr.

DID YOU KNOW THAT—

JOE MARION and his JOLLY GANG will be back with us soon? Watch and wait for the opening date and then come and greet funny little Joe when he opens his summer engagement. His company is even better than ever and Kearney is assured of some great shows from Joe this summer.

During the month of May the World will present talking pictures that are the talk of the entire country.

THE BROADWAY MELODY, the all-talking, singing sensation that has taken the country by storm will soon be presented at the World.

WHEN IN OMAHA ATTEND THE WORLD THEATRE— ALWAYS A GREAT SHOW.

COMING SOON

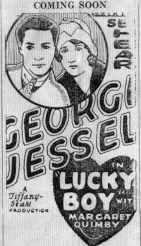

THE ORIGINAL
JAZZ SINGER
Hear Him Sing
"My Mother's Eyes"
"Old Man Sunshine"
"My Black Birds Are Blue Birds Now"
AND OTHERS

MAMMOTH ARRAY OF GREATER 'TALKIES' BOOKED FOR NEXT MONTH

Mary Pickford's "Coquette" opens a month of the greatest talking and sound pictures obtainable for immediately following this great all-talkie the World will offer an array of talkies at our favorite popular prices that will be town talk for months to come. First comes George Jessel, the original New York Jazz Singer, in "Lucky Boy" his first talking and singing production. Everyone is familiar with the name of George Jessel whose name has been on the bright lights of Broadway for many seasons. The picture includes several scenes of dialogue and Jessel sings several songs the best known of which are "My Mother's Eyes", the theme song; "Old Man Sunshine". "My Blackbirds are Bluebirds Now"; "My Boquet of Memories" and others.

Following "Lucky Boy" is Douglas Fairbanks "The Iron Mask" which is a sequel to the famous "Three Musketeers". Douglas will talk to you in this picture. Following this is the picture that is taking the country by storm, 'The Broadway Melody" that all-singing, talking and dancing sensation starring Bessie Love, Anita Page and Charles King.

Following the "Broadway Melody" is that great all-talking mystery drama, "The Donavan Affair" starring Jack Holt and Dorothy Revier. The week following this the World will present "The Bridge of San Luis Rey" another talking sensation starring Ernest Torrence, Raquel Torres and Don Alvarado. In th near future Kearney will welcome back Funny Little Joe Marion and his gang and as a screen attraction to be shown in conjunction with his return is another super-talking picture that is creating a sensation throughout the country, "The Bellamy Trial."

— IT'S COMING SOON —

"The Broadway Melody"
THE ALL TALKING — SINGING — DANCING SENSATION OF THE YEAR

ASK TO HAVE YOUR NAME PLACED ON OUR MAILING LIST

International House played at the World in June 1933. That month, the *Kearney Hub* also indicated that along with it would be a newsreel featuring Nebraskan Johnny Goodman, who as an amateur won the US Open the same year, and a short documentary film describing the eruption of Krakatoa years earlier. The main feature, *International House*, was available before the Hays Code was adopted in 1934 and dropped in 1968. This set of censorship guidelines imposed by the industry on itself was intended to ensure studios were creating proper family entertainment and broadly specified that movies should not lower the moral principles of those seeing them, depict improper standards of life, or ridicule the law. It also had much more specific restrictions regarding language, the sanctity of marriage, religion, and other topics. The movie included scantily clad dancing "girls in cellophane," Cab Calloway singing *Reefer Man* about a pot smoker, and plenty of double entendres delivered by W.C. Fields. (Courtesy of Russ Erpelding.)

According to the *Antelope* student newspaper at the Nebraska State Teachers College at Kearney (now the University of Nebraska at Kearney), it was "All-college Theater Night" at the World on April 12, 1934. Members of the junior class were raising funds for the annual junior-senior banquet and were selling event tickets. The film shown was *Beloved*, a dramatic romance starring John Boles and Gloria Stuart. The story followed Boles, an Austrian composer, over the course of many years and the many upheavals he experienced to complete a symphony he started years earlier. Campus entertainers served as the encore for the movie with Paul Pence from the music department who sang *Wagon Wheels* and *Smoke Gets in Your Eyes*. Afterwards, Leo Walker played a few tunes on his accordion, and Wayne Wilson and Stan Newman, both college cheerleaders, provided spirited yells and songs for the 200 attendees. This photograph shows students and faculty on the walk in front of Old Main, the original administration building, at the Nebraska State Teachers College in 1934. (Courtesy of the University of Nebraska at Kearney.)

The stock market crash of October 29, 1929, marked the unofficial beginning of the Great Depression, which lasted about 10 years. During it, unemployment reached 25 percent, and about half of the country's banks failed, wiping out many citizens' savings. On July 11, 1934, the *Kearney Hub* reported that an event would take place at the World the next morning and admission would be two usable fruit jars. These jars were distributed to needy Kearney families for canning fruits and vegetables for winter consumption. The features included a Western with Randolph Scott titled *Sunset Pass*, a 19-minute comedy, and a *Popeye the Sailor* cartoon. Shown is part of a packet distributed at the World containing the lyrics and musical notes of *Let Me Stray*. It is likely the song was featured in that week's movie. (Courtesy of June and Steele Becker.)

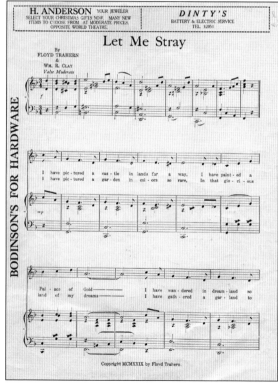

By 1934, many people were questioning themes and language in cinematic productions. Nationally, church organizations exercised their clout and boycotted some films, calling them "soiled celluloid," and local efforts to inform patrons of content were initiated. On June 1, 1935, the *Kearney Hub* ran frank reviews of films at the World and the Empress (below) that were authored by the Better Films Council of Kearney, Nebraska. For films at the World that week, the council's members wrote that "[the heroine] makes incredible asses of strong men," "for adults, sadistic drama," "stupid as drama, needlessly gruesome," and "another murder-mystery melodrama running true to usual." These reviews by the council appeared in the paper for about a year and were in glaring contrast to those provided by the studios. (At right, courtesy of Russ Erpelding; below, the Buffalo County Historical Society.)

WORLD THEATRE NEWS
THE GREATER TALKIE THEATRE

POSITIVELY THE FINAL WEEK
R. J. McOWEN, PRESENTS
"THE PIED PIPERS" and the WORLD PLAYERS—offering
GEO. ANGEL'S RURAL COMEDY DRAMA

"SMILES"

Produced under the personal direction of Billy Trout.

CAST OF CHARACTERS

Jethro Edwards	Arte Holbrook
Stutters	Clyde Davis
Elizabeth Edwards	Vera Reno
Adel Williams	Bee Chapman
Jennie	Joye Martin
William Lane	Billy Trout
Captain Sam Smith	Earl Gregg
Smiles Edwards	Elmore Gailey

SYNOPSIS OF SCENES

ACT I.—Smiles Edwards' home—evening, 1918.
ACT II.—Same—The next morning.
ACT III.—Same—Several days later.

COMING SOON
ALL TALKING — SINGING — DANCING

"BROADWAY MELODY"

BETTER THAN A $6.60 MUSICAL SHOW

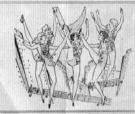

NEXT MONDAY AND TUESDAY
4 — Acts Association Junior Orpheum Vaudeville — 4

TWO HEADLINERS

ETHEL KENNEDY REVUE	BUD POLLARD'S GOOFY-TONE
Cast Of Four	Not Movieton or Vitaphone, but Goofy-Tone

ASK TO HAVE YOUR NAME PLACED ON OUR MAILING LIST

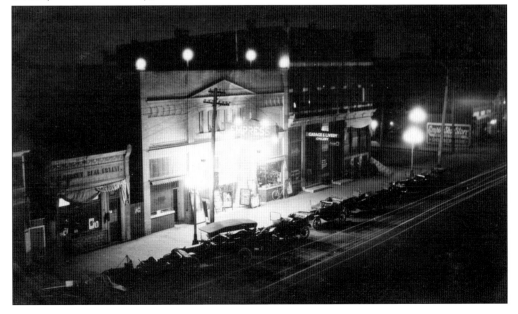

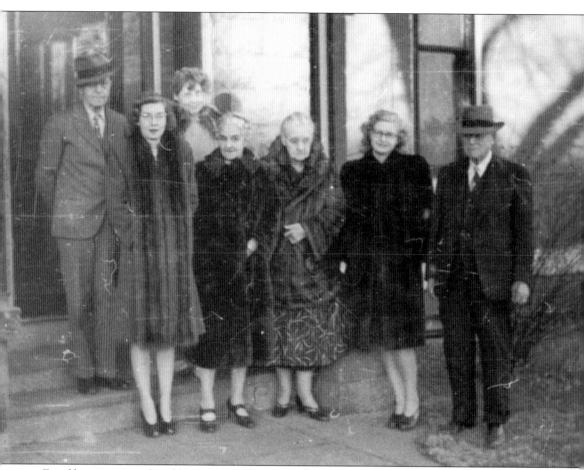

Few films got as much publicity in the *Kearney Hub* as did the *Wizard of Oz*. It was scheduled at the World for August 27 and 28 in 1939, but it drew such large crowds that it was held over. The prizes for the best entry out of more than 150 submitted in a *Kearney Hub* Wizard of Oz Contest was a ticket to the film and a book titled the *Wonderful Wizard of Oz* by L. Frank Baum from which the movie was produced. These were awarded to Dorothy Brun. Free tickets to the film were given to 30 runners-up and one was Emma Jane Wilder. She remembered that the movie was unique as the imagery changed from black and white to color when Dorothy looked out the door of her transplanted farmhouse. Doralene Weed recalls seeing a Tin Man in front of the World at the premiere, and an August 25 *Hub* ad suggests that there indeed was. The young woman to the front left is Emma Jane about the time she won her ticket. (Courtesy of Emma Jane Wilder.)

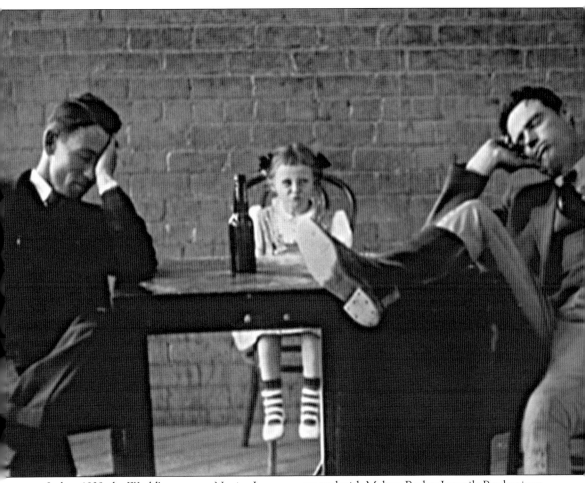

In late 1939, the World's manager, Nevins Lynn, contracted with Melton Barker Juvenile Productions to shoot a film locally that was similar in content to the *Our Gang* comedies, and it was titled the *Kidnapper's Foil*. Approximately 75 Kearney youngsters aged 3 through 12 were cast in it after they submitted an application at the World, paid a few dollars, and went through a screen test. On November 21, 1939, the *Kearney Hub* indicated that a cinematographer and soundman from the company were ready to begin work, and some scenes were shot on the World's stage Friday evening, December 1, 1939. Lynn orchestrated the whole project so that Kearney kids could see and hear themselves on screen and compare their acting, singing, and dancing abilities to those of Shirley Temple, Freddie Bartholomew, and Spanky McFarland. The film premiered at the World on December 13, 1939. This image, with Melton Barker on the right, is from the *Kidnapper's Foil* shot in Childress, Texas; he produced this same movie in many communities. (Courtesy of the Texas Archive of the Moving Image, www.texasarchive.org.)

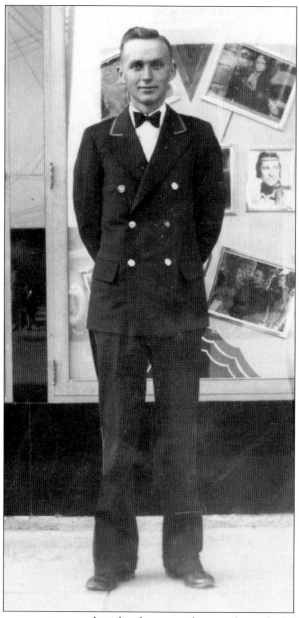

Late-night showings were not unusual at the theater and were often scheduled on dates such as Halloween when audience members might be in a celebratory mood and out on the town. On New Year's Eve in 1939, the World's manager slated a Midnight Frolic that included the standard fare plus bonus entertainment. This particular event was open to men and women and featured a cow-milking contest, presumably on stage. In the timed competition, contestants tugged the udders of bovine in an attempt to accumulate as much milk in their pails as they could. The three with the most at the end of 60 seconds split $15. The champ from the year before, Rodney Nichols of Gibbon, entered to defend his title, but unfortunately the names of the winners were not published in the *Kearney Hub* afterwards. The feature film that evening was *Cisco Kid and the Lady* with Marjorie Weaver, Cesar Romero, and Virginia Field. Shown here is Clinton Smestad outside a theater in the late 1930s before he managed the World. (Courtesy of Mary Smestad Krecek.)

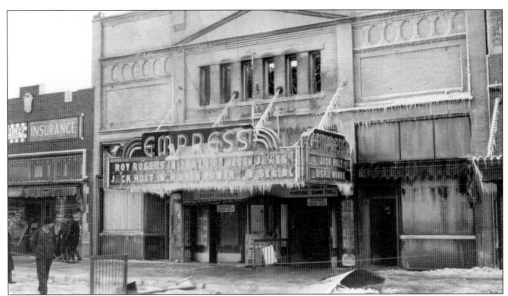

Several days of bitterly cold temperatures preceded a fire that burned the World's sister operation, the Empress. The *Kearney Hub* reported on January 19, 1940, that the fire started at 8:30 p.m. the night before during a performance. Speculation was that it occurred as the result of cardboard being too close to the furnace or a wiring problem near the coal room. Patrolman Archie Bell and doorman Glen Asher had difficulty getting theater patrons to "make an orderly departure," and there were problems "keeping spectators out of the theater lobby after the fire developed." Above is the Empress immediately after the fire, showing its entry roped off because ice formed as the result of water from fire hoses. At right is the World's original coal-fired furnace. (Above, courtesy of the Buffalo County Historical Society; at right, the World Theatre Foundation.)

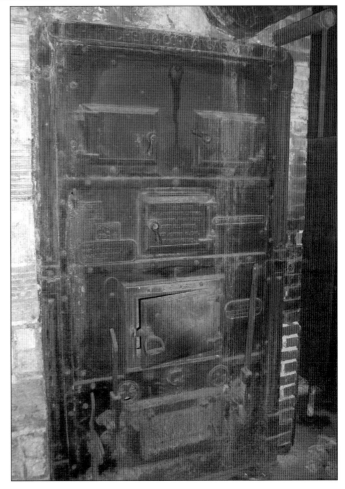

First Session
Cooking School Program
Presented by DOROTHY GILL

No. 1. LEMON ICE CREAM

1 1-3 cups sugar
1 2-3 cups milk
Juice of 2 lemons

Grated rind 1 lemon
1 cup cream, whipped stiff

Combine sugar, milk, lemon juice and rind. Add cream. Place in refrigerator trays. Stir once or twice while freezing. 1 small can crushed pineapple may be added.

No. 2. SPICY BANANA CAKE

½ cup butter or shortening
1¾ cups sugar
2 eggs
1 cup mashed bananas (ripe)
2½ cups OMAR WONDER FLOUR
3 teaspoons KC Baking Powder
½ teaspoon soda

½ teaspoon salt
¼ teaspoon nutmeg
½ teaspoon cinnamon
¼ teaspoon allspice
1 cup sour milk or buttermilk
½ cup chopped pecans or walnuts

If part shortening is used, add ¼ teaspoon salt. Cream butter or shortening and add sugar gradually. Cream light. Add eggs one at a time and beat well. Add mashed banana pulp and blend. Sift OMAR WONDER FLOUR once, measure. Sift flour, baking powder, soda, salt and spices together twice. Add dry ingredients alternately with milk. Add chopped nuts. Pour into a greased 9x13-inch cake pan. Bake in a moderate oven (350° F.) for 40 to 45 minutes. Cool; ice with any desired frosting or top with whipped cream, garnishing with sliced bananas.

In 1940, the World Theatre's stage was converted into a functioning kitchen equipped with appliances that were considered modern at the time. All of this was done because Dorothy Gill, well known for home economics sponsored by the *Kearney Hub*, was in town to conduct a free three-day homemaking seminar. She was extremely popular, having been there during the two previous years. The February 7 *Kearney Hub* reported that more than 1,000 locals crowded into the World to attend day one of the event to learn the latest in the culinary arts, including cooking techniques and recipes. There was also a fashion show featuring clothing from Kearney retailers and a cleaning demonstration. The total attendance for the sessions in 1940 was approximately 3,000 people. (Courtesy of Doralene Weed, Rachel Robbins' images.)

Second Session
COOKING SCHOOL PROGRAM
Presented by DOROTHY GILL

No. 1 APRICOT CREAM PIE

1 tablespoon gelatine
1 tablespoon cold water
½ cup apricot juice
6 tablespoons OMAR FLOUR
⅓ cup sugar
½ teaspoon salt
1½ cups scalded milk
2 egg yolks

1 teaspoon vanilla

2 egg whites
⅓ cup sugar
1 cup whipping cream
1 baked pie shell
6 apricot halves

Sprinkle gelatine with cold water. Add ½ cup hot apricot juice and stir until dissolved. Sift flour once, measure. Blend flour, sugar and salt and add hot milk. Cook in double boiler, stirring constantly until thick and smooth. Cook ten minutes longer. Remove and add gradually to slightly beaten egg yolks, then return to the fire and cook two minutes longer. Add apricot juice mixture and vanilla. Cool. Beat egg whites with ⅓ cup sugar until stiff, but not dry. Fold into cooled custard mixture. Fold in ½ cup cream, beaten stiff. Pour into baked pie shell. Chill until firm. Garnish with remainder of cream, whipped and sweetened, and apricot halves.

No. 2 REFRIGERATOR ROLLS

1 cake compressed yeast
1½ cups milk (scalded and cooled to lukewarm)
6 tablespoons sugar

1 teaspoon salt
2 eggs
6 cups OMAR FLOUR
½ cup melted shortening

Crumble the yeast. Add the milk slowly and stir until dissolved. Add the sugar, salt and beaten eggs. Sift flour once, measure. Add

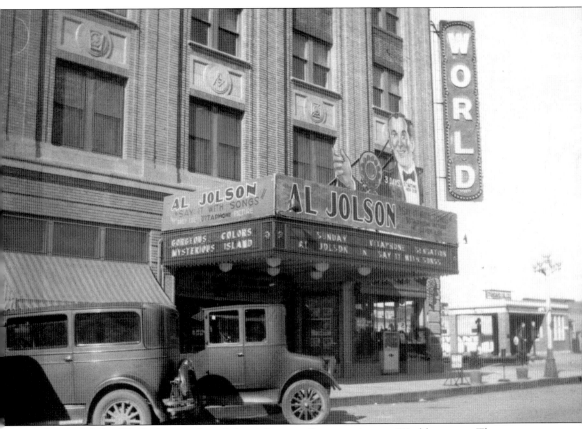

In 1940, John W. Gerber purchased the rights to sell concessions to World patrons. The owners, the General Theatre Corporation, did not allow the sale of drinks, candy, ice cream, and other such snacks in the movie house; however, Gerber was permitted to sell them in the space just south of the theater entrance yet still in the Masonic Temple building. According to John D. Gerber, the son of the owner, the film experience at the time was considered an art form and was intended for respectable people. According to *Cinema Houston: From Nickelodeon to Megaplex*, in-house concession operations "had long been associated with low-class entertainment such as burlesque and carnival shows. Theater owners were trying to fight the image of movies being entertainment for the lower classes." Gerber's would eventually reside in the space with the striped awning in the picture. (Courtesy of the Buffalo County Historical Society.)

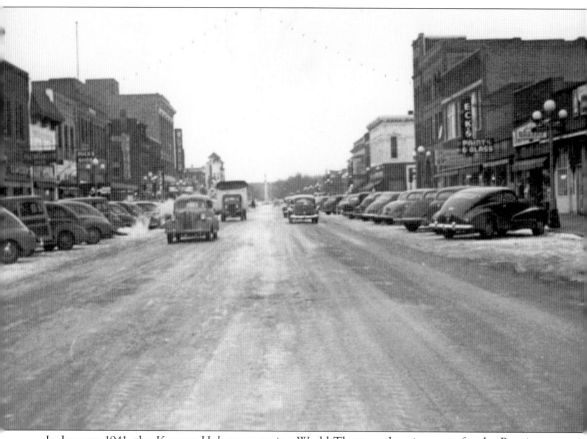

In January 1941, the *Kearney Hub* was carrying World Theatre advertisements for the *Burning Question*. The ads contained phrases such as, "Special midnight show," "Sensational expose," "Adults only," and "Innocent youth, victims of the new sex-craze love weed." Initially titled *Tell Your Children*, it was produced to warn of the dangers of smoking marijuana. In the film, a group of young people is lured into pot's embrace when they experiment with or somehow mistake cannabis for cigarettes. The weed caused them to separately hit a pedestrian while driving, rape a woman, be committed to an asylum, be sent to prison, die after jumping from a building, and shoot or beat another person to death. Eventually, it became known as a classic, not because of the seriousness of its message but because of bad acting and unintended comical depictions. The title was changed several times, but it is most popularly known as *Reefer Madness*. (Courtesy of the Buffalo County Historical Society.)

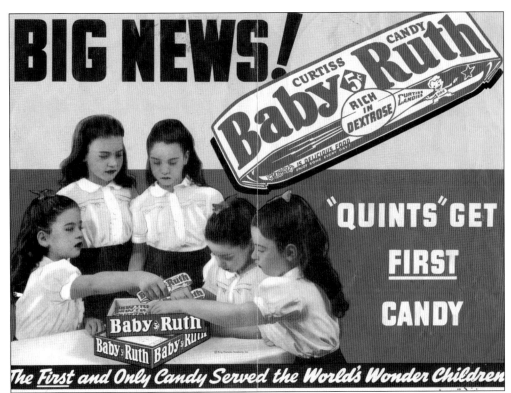

The authors of *Cinema Houston: From Nickelodeon to Megaplex* indicate that, for vendors, locations near theaters were profitable spots, because audiences turned over frequently. Once he took possession of what would become the Sweet Shop, John W. Gerber gave it a good cleaning, modernized it, bought a new Manley popcorn popper, and expanded the selection of products for sale. Friends and family did not initially encourage the gamble he took to acquire the lease, but it soon paid off for him. The Dionne quintuplets, seen above, appeared in theater and candy store advertisements during the 1940s and 1950s and, having survived infancy, were considered marvels. Below is a reminder that food supplies were limited during World War II. (Above, image provided by Dr. Walter Martin of Fort Theatre Dentistry, courtesy of Nestlé; below, the Buffalo County Historical Society.)

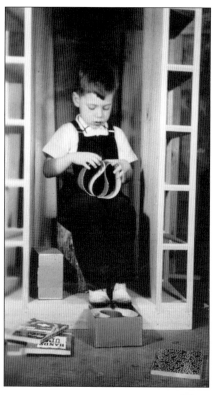

In 1943, there was $14,000 worth of individual boxes of popcorn sold from Gerber's Sweet Shop. By this time, theater operators saw that concessions sales were an important revenue stream—and popcorn was a cash cow. Members of the General Theatre Corporation, which owned the World, noted the success Gerber was having and attempted several times to buy out his lease. These efforts occurred simultaneously with increasing costs of studio movie rentals and necessary theater upgrades to accommodate producers' film requirements. The corporate leaders built their own concession stand inside the theater when Gerber's contract expired in 1948. John D. Gerber is seated at left inside a display cabinet his father constructed for the Sweet Shop. Below is an old popcorn box found in 2010 during the World's renovation. (At left, courtesy of John D. Gerber; below, the World Theatre Foundation.)

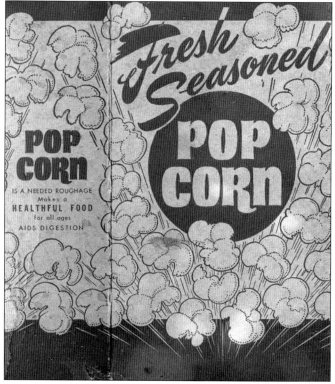

John Gerber

ADMIT ONE BOND BUYER

BUFFALO COUNTY VICTORY BOND DRIVE CELEBRATION

KEARNEY, NEBR.

WORLD THEATRE
Friday, December 7th, 1945
8:00 P. M.

Direct US involvement in World War II began December 7, 1941, and ended on September 2, 1945. US military expenditures outpaced available capital, so interest-bearing Victory Bonds in varying amounts were sold to Americans during and even after the war. On December 7, 1945, the *Kearney Hub* reported that Buffalo County sold 138 percent of its quota in the final drive and locals celebrated at the World that day. Appearing was Nebraska governor Dwight Griswold, who thanked residents for sacrificing much to support the troops. Ruth Hulse Nelson played the organ, the Squadronaires from the Kearney Army Airfield and the Jive Five performed, and Norma Schnier and Art Vandimere sang. Later, the movie *Dangerous Partners* was shown. The war was over, but rationing of many commodities continued until 1946. (Above, courtesy of John D. Gerber; below, the Buffalo County Historical Society.)

49

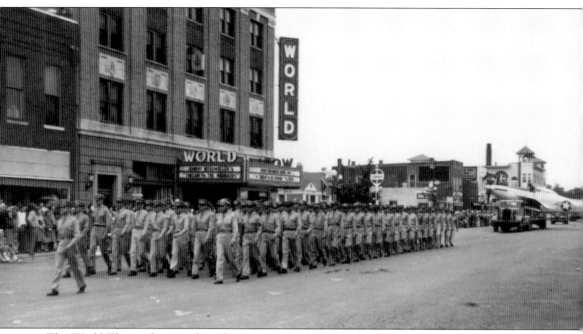

The World Theatre has stood on the corner of Twenty-fourth Street and Central Avenue since 1927 and has observed the growth of a city, storms of all sorts, changes in fashion, loads of holiday shoppers, disastrous fires, and sunrises each and every day. It also saw nearly 20,000 people line the street on June 12, 1948, when the community celebrated its Diamond Jubilee with the biggest parade ever held in Kearney up to that time. This three-day 75th birthday party included a Saturday morning procession that included an estimated 70 floats created by a variety of groups from Kearney and surrounding towns. The June 12, 1948, *Kearney Hub* provided detailed descriptions of many of the celebration's participants, including the 165 Air Force enlisted men shown here marching past the World that day. Their parade float, which was the largest, was a truck hauling a P-81 Mustang fighter plane, as seen to the extreme right in the photograph. (Courtesy of Harold and Inez Albrecht.)

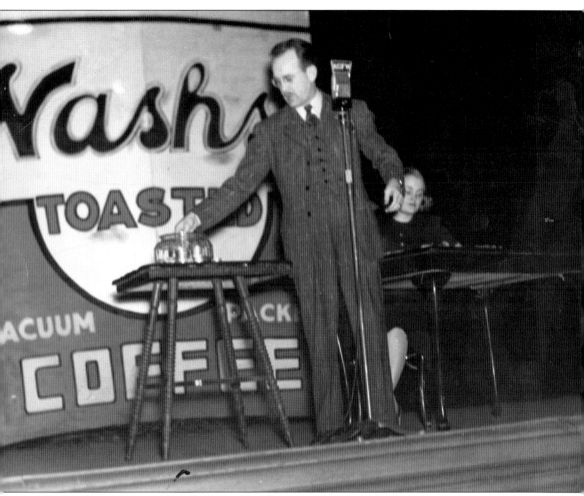

On Saturdays in the mid-1940s and early 1950s, the World was the domain of young kids there to see the adventures of their favorite Western stars. As they grew older, Sunday became the preferred day to go because musicals were often shown then, and films from that genre became the favorite as the audience aged. Especially enjoyed were those with Dan Dailey, Betty Grable, Ginger Rogers, Fred Astaire, Gene Kelly, Debbie Reynolds, Eddie Fisher, and others. Memorable titles were *An American in Paris, Brigadoon, Holiday Inn, Oklahoma, Singin' in the Rain, Show Boat*, and *White Christmas*. These were attractive not only for their story lines, singing, and dancing, but also the quality of the lyrics and melodies. Many of the best songwriters and composers in this class of film had come from Broadway or had been bandleaders or composers before applying their skills in Hollywood. This photograph from the late 1940s shows KGFW-AM announcer and manager Anson Thomas hosting a live radio broadcast of the *Nash Coffee Quiz* from the World's stage. (Courtesy of KGFW Radio/NRG Media.)

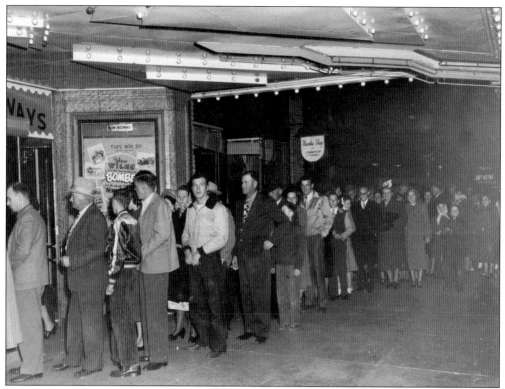

DeLoss Wilke, born in Sweetwater, Nebraska, spent his early years working with livestock on the family farm. Later, he was a sale barn auctioneer, an animal judge in county fairs, and a rodeo operator. According to his daughter Jean Randolph, he was "cowboy to the core." He had a talent for teaching animals to perform for audiences, and he made a career of driving them around the country to appear in events of all sorts. On November 29, 1949, the crowd above is lined up outside the World to see DeLoss, his trained Brahman named Bomber, and Golden Spike, a palomino. The three are shown below, possibly on stage at the World and probably the same night. Wilke and his companions eventually became celebrities and appeared with Roy Rogers, Dale Evans, Gene Autry, and others. (Courtesy of the Randolph family.)

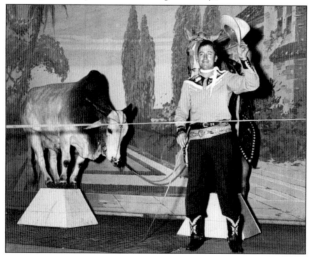

Low-budget horror movies, according to *Ghouls, Gimmicks, and Gold: Horror Films and the American Movie Business 1953–1968*, flourished during the 1950s because of a 1948 Supreme Court decision requiring the five biggest studios to eliminate monopolistic control of the film industry. As a result, more cheaply made titles were released, targeting an attractive demographic—teens with disposable income. A *Kearney Hub* ad from July 5, 1951, for the *Thing* indicated that "no one will be seated during the last 7 minutes because you need a gradual build-up to stand the terrific, shocking climax." Nationally, many creative managers also devised thrilling interactive experiences for audiences. On September 9, 1952, the *Hub* shows that *Black Dragon* was slated and Dr. Chan Loo would appear on stage with *Horrors of the Orient*. Also appearing were the Wolf Man, Igor the Hunchback, and the Living Zombie. Readers were forewarned, "If you have a weak heart, better stay home." These tickets were from *Scared Stiff*, shown at the World on June 21, 1953. (Courtesy of and in loving memory of Moniema [Andresen] Niemeyer from her family.)

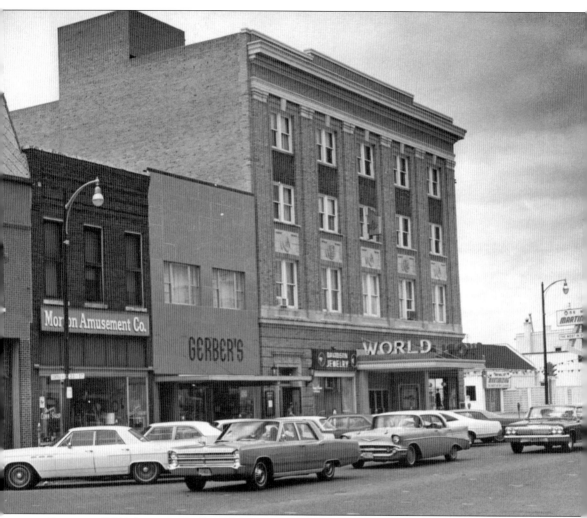

Featuring "1001 fantastic thrills and 1001 fabulous sights," *Captain Sindbad* opened at the World on October 5, 1963, according to the *Kearney Hub* a few days earlier. In the starring role was Guy Williams, who later played Prof. John Robinson in the *Lost in Space* series. Over the years, a vast number of film production processes were developed to enhance the public's movie-viewing experiences and allow theaters to compete with other available media. Some of these included Cinemascope, a method of cheaply creating wide-screen images, Technicolor, which allowed producers to create color films such as the *Wizard of Oz* using dyes to alter black and white film, and Dolby stereo, which improved sound clarity and reduced unwanted noise. Some techniques, such as Wondra-Scope, a technique touted as being used in *Captain Sindbad*, were completely bogus terms invented to hoodwink potential ticket buyers into believing a film was magnificently different in some way. According to *Cinema Houston: from Nickelodeon to Megaplex*, other similar dubious techniques were Illusion-O, Aromarama, Percepto, Fantamation, and Hypnovision. (Courtesy of the *Kearney Hub*.)

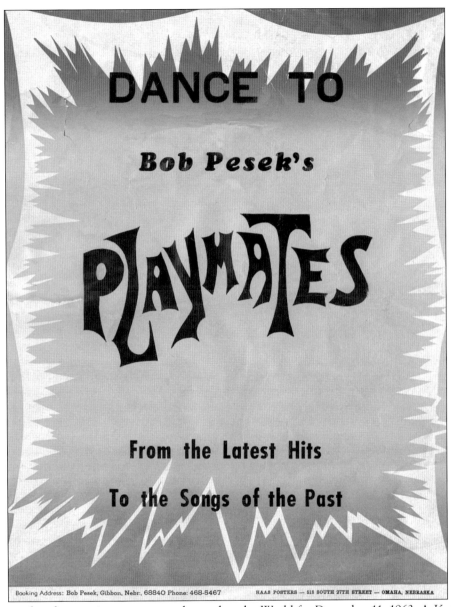

DANCE TO

Bob Pesek's

PLAYMATES

From the Latest Hits

To the Songs of the Past

Booking Address: Bob Pesek, Gibbon, Nebr., 68840 Phone: 468-5467 HAAS POSTERS — 618 SOUTH 27TH STREET — OMAHA, NEBRASKA

A big night of entertainment was on the card at the World for December 11, 1963. A *Kearney Hub* display ad for the theater that day included studio-supplied artwork for the *Young Swingers* and *Hootenanny Hoot*, both of which apparently featured thin plots and bad acting but lots of young people singing, dancing, and having 1960s-style fun. The highlight of the night may have been performances by Pesek's Playmates, a local group, interspersed between the movies and the on-stage talent competition among Kearney citizens. The Playmates included Bob Pesek on accordion, Tom and Huby Woitercheski playing rhythm guitar and drums, Bud Robinson with the bass guitar, Bob Ayres on the lead guitar, and Gary Camp on the alto saxophone. According to Ayres, the group's repertoire consisted of surfing music such as *Little Deuce Coupe*, folk music tunes like *Tom Dooley*, and dance tunes including *There is a Summer Place*. The winner of the competition that night was Richard Hite, who sang *Old Dog Blue* a cappella style. (Courtesy of Bob Pesek.)

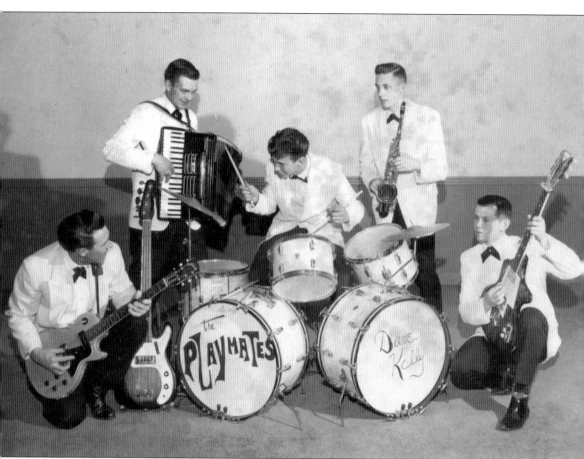

Pesek's Playmates were hired to play at another event that took place on the World's stage in the 1960s and was intended exclusively for the region's Chevrolet dealers, their salespeople, and mechanics. Bob Pesek recalls that the gathering served as the local rollout for the brand's lineup of muscle cars, and he estimated that there were about 500 people in the audience who were there to see the new high-performance Chevrolet street machines that were parked in front of the theater, among other things. Inside, the attendees were treated to a promotional film with actress, singer, and television star Dinah Shore belting out the anthem she performed for her sponsor for almost two decades, *See the U.S.A. in your Chevrolet.* A number of speakers took the stage, presumably to hype the vehicles, and between all of these, the Playmates churned out entertaining tunes. (Courtesy of Bob Pesek.)

Three

TALES OF THE WORLD

Thousands of patrons, performers, employees, and others have been in and out of the World since it opened in 1927. Those who went there to see films seem to share commonalities, regardless of their ages or the decades that they frequented the place. Ticket buyers tend to talk about the aroma of the buttered popcorn, buying cold drinks from the concessions stand or the vending machine, sitting in choice locations, including the coveted but seldom available balcony, and seeing productions that are still memorable years after they were originally shown.

Additionally, hundreds of local people have worked at the theater over the years. Some were there as high school or college students, a number stayed just for short periods of time, a few were on the payroll long enough to have called their employment there a career, and many said they received their very first paychecks as World staffers. All of them have different yet extremely positive memories about aspects of the World such as showing blockbusters, seeing the crowds, and witnessing special events, but they primarily talk about their relationships with all of those who were World employees and managers.

The World may have been a fun, safe, and relaxing place for patrons and employees alike, but underlying those issues is the fact that it was a commercial venture and existed in a competitive and dynamic market. According to the facility's last manager, Dick Smith, being part of a theater chain had advantages when it came to working with film distributors. He said one Kearney theater was offered *Batman*, but the terms included an exorbitant $25,000 fee plus a percentage of ticket sales over a specific number of weeks. A huge chain operation, with hundreds of screens and thousands of prospective ticket buyers, is better able to negotiate such terms since its significant revenue potential is very appealing to distributors. For example, percentages can be contracted to drop at intervals the longer a film is presented. Though, in many cases, movie house operators often do not make money until several weeks after a premier, if they make money at all. Independent theaters and those in small chains, like the World, have very little clout when bargaining for titles.

The Kearney Masons intended for the World to fill a specific niche and to last a very long time, not only for their organization's benefit but for Kearney citizenry as well. The stories here suggest that, nearly 100 years after the original vision for the facility was articulated, the place is still meaningful to members of the community and, as a result, continues to serve its intended purposes.

Olive Cleland, born in 1912, played music at the World, the Empress, and the Crescent as a young woman. For little or no pay, she would accompany silent movies on the piano and the violin; however, audiences preferred that she play the tenor banjo during comedies as it apparently produced sound more appropriately fitting humorous fare. She remembers that the new World was "a beautiful theater." During the early 1930s, visits to the theater were supposed to help people forget the dismal economic situation, so the manager of the World decided it should not only have appealing music and films, but that it should look pleasant, too. He turned to Kearney Floral. Jack Erickson, whose parents owned the florist shop, was charged with the weekly duty to deliver an assortment of flowers. He initially did so using his tricycle, and later a bicycle, with a wagon pulled behind it. Shown on the right is flower deliveryman Jack Erickson with his lifelong friend Charles Oldfather. (Courtesy of Joan Erickson.)

World Theatre Trade Coupon

This Coupon Good for 15¢ on a Dollar Purchase
At Any of the Following Merchants

Scotts Furniture	Palace Drug Store
I. G. A. Store	Hirschfeld Clothing Co.
Baumgartner's Variety	Bodinson Hardware
Haeberle Drug Store	Gray Sterling Clothier
Brown McDonald Co.	Kearney Hardware

O. K. Campbell Shell Service

Get a Coupon every SATURDAY AT THE
WORLD THEATRE. This Coupon Good Until
APRIL 30, 1937.

Sign of the Cross by Cecil B. DeMille played at the World in February 1933 according to the *Kearney Hub*, and 11-year-old Jerry Pickerell said he was required to take a dime to school because he, his classmates, and his teachers went to see it. He still remembers a scene in which Christians are supposedly slaughtered in a Roman arena; the imagery brought tears to his young eyes. In 1940, the classic *Gone with the Wind* was shown at the World a total of 20 times during a seven-day period. An unusual arrangement was that seats for most showings were reserved, hinting at its popularity. On March 23, a *Kearney Hub* writer stated, "The picture is heavily laden with sadness and scenes that are not pleasant to the eye but it also shows much of the gaiety, the chivalry, and the richness of the old south." (Courtesy of the parents of Tom Reidy.)

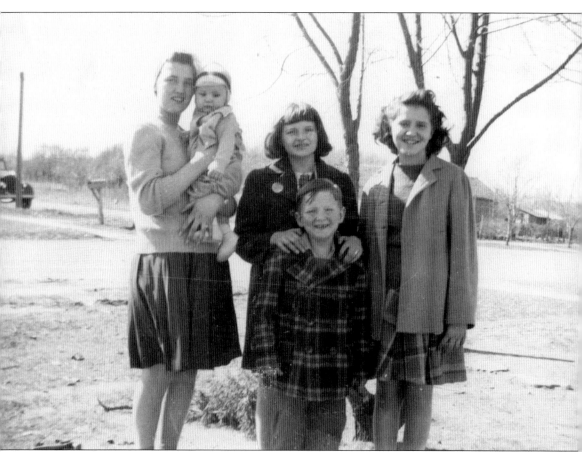

Seen here are the McDowell children. From left to right they are Betty, 14; David, infant; Phyllis, 10; Raymond, 5; and Deloris, 12. Theirs was a family that enjoyed music; their father played piano in a band, and the family regularly engaged in sing-alongs at home and practiced harmonizing with one another in the car. By the time this photograph was taken in 1945, the McDowell girls had a reputation as accomplished singers, and they regularly performed at Kearney weddings and funerals. The same year, there was a youth talent competition at the World, and the young ladies were keen to enter, but according to Deloris, Betty stayed at home that day to assist their arthritic mother. For her number, Deloris sang *Beautiful Dreamer*, won the contest, and was awarded a silver dollar, which was a significant amount of money for a young person then. Her sister Phyllis won a 50¢ piece, but tragically, she never made it home with the coin. It slipped from her hand and rolled into one of the theater's floor vents, never to be seen again. (Courtesy of Deloris McDowell.)

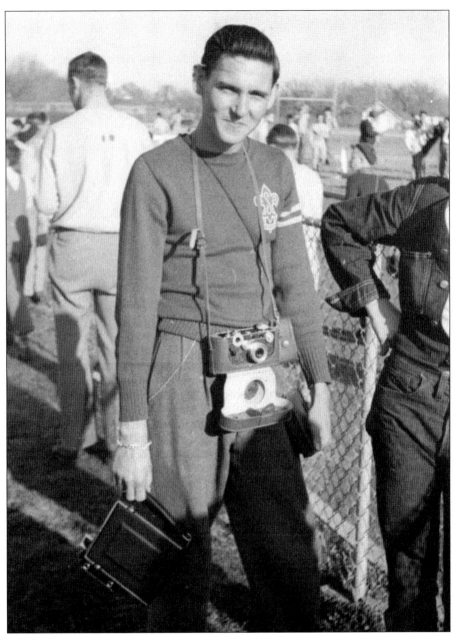

Ward Schrack is shown here as a high school student around 1945 when he worked at the World for 50¢ an hour changing the lettering on the marquee above the front doors of the theater. He said the letters were made of a fragile Masonite-type material, and because he did his work on a ladder, it was inevitable that some were occasionally broken. Schrack also said that the World was an important place for young people who were leaving childhood behind and edging toward courtship and relationships. The World was one of the few places in town where teens could go for hours of affordable entertainment, it was a public place yet had intimate spaces, and it was safe. According to Ward, lots of relationships started after the show ended when patrons gathered in front of the World and engaged in conversation, planned another date, talked about the film just seen, and walked friends home. (Courtesy of Ward Schrack.)

Mel Wattles was a ticket-taker, and he changed the marquee each week starting at age 17 in 1948. Late one cold November evening, he got a call at home and it was the World's manager at the time, Joseph Cole. He wanted Wattles to return to the theater to correct the marquee, because "Burt Lancaster's name did not have a 'd' in it." If a popular movie was shown, he would be an usher and was responsible for ensuring that all of the auditorium's seats were occupied to maximize profit. This meant he had to get patrons to sit in the front rows or ask couples to fill two empty, separated seats. Mel, on the far right, is seen in 1948 at Lantz's Drugstore, which was two blocks south of the World. (Above, courtesy of Mel Wattles; below, Fort Theatre Dentistry.)

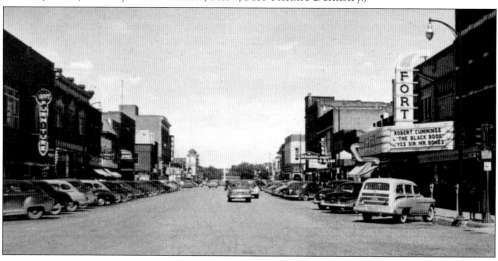

Jim Cudaback took the "Motor," a gas-powered train car that cost 20¢ to ride, and traveled from his hometown of Riverdale to Kearney in about 20 minutes to see films at the World on Saturdays when he was young. Cudaback, at right, saw *House of Wax* with Vincent Price in 1953 at the movie house, which was exciting because it was in 3-D. He remembered one scene in which a character playing with a paddleball turns toward the camera and smacks the object at the audience repeatedly. Jim said that he was bobbing and weaving to avoid being hit by it. Below are Moniema Niemeyer's 3-D mementos from *House of Wax*, shown at the World on June 28, 1953. (At right, courtesy of Jim Cudaback; below, courtesy of and in loving memory of Moniema [Andresen] Niemeyer from her family.)

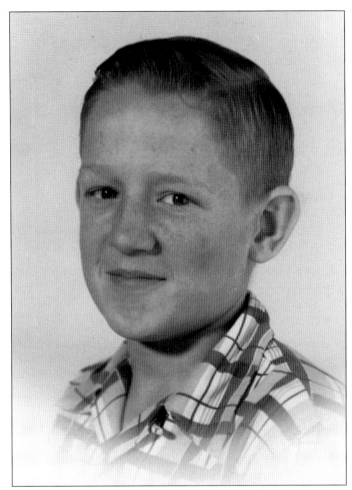

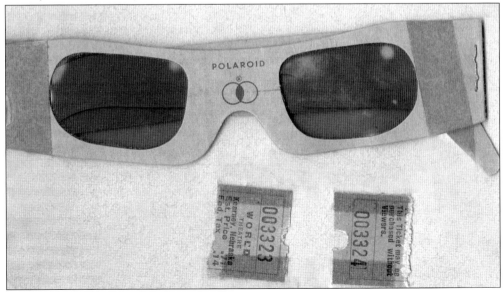

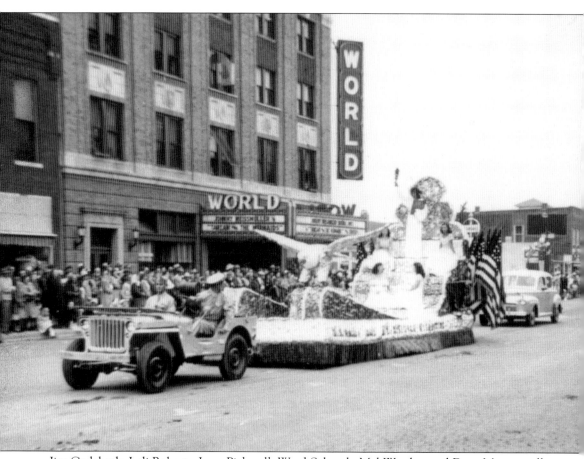

Jim Cudaback, Judi Roberts, Jerry Pickerell, Ward Schrack, Mel Wattles, and Dave Mattson all stated separately that during their childhood era of the mid-1940s to early 1950s youngsters lived for the Saturday matinee at the World. There was usually an action-packed Western with Roy Rogers, Gene Autry, Hoot Gibson, or Hopalong Cassidy and a serial with a cliffhanger to keep kids coming back week after week. Gwen Traxler and Harry Compton remember a guest appearance at the theater in which Rex Allen, "the Arizona Cowboy," appeared on stage with his trusted horse Koko. In Kearney, the film and recording star was dressed in his signature Western attire, sang a few songs, did some rope tricks, and tossed small bags of candy to thrilled audience members. This photograph shows the Army Recruiting Service float in the 1948 Kearney Diamond Jubilee parade. The *Kearney Hub* reported it had "girls, flags, a Statue of Liberty, and an eagle." (Courtesy of Harold and Inez Albrecht.)

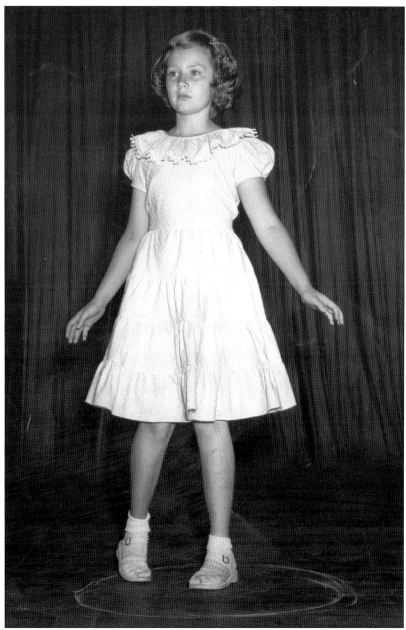

From the time that it opened, the World's stage was frequented by local residents almost as often as professional performers, and there were occasions where there were very young people in the starring roles. Prettiest Baby and Cutest Kid contests were popular at the theater as early as 1930, and these were probably effective at luring entire families into the auditorium for the contest and the movie. One such event took place in the late 1940s, and people voted at local merchants' businesses where they dropped pennies in jars belonging to good-looking youngsters. Joyce Heiden won the title that day and received prizes from stores around town. In this picture, young Judi Miller is showing off the newest styles at the World for a downtown clothing store around 1951. She remembers wearing two different dresses and using the same backstage dressing rooms used by professional entertainers and vaudevillians. (Courtesy of Judi Roberts.)

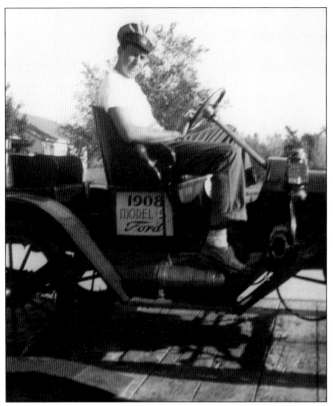

In 1951, the B.F. Winslow & Sons painting company did some work at the World, and Marlin Heiden, seen at left around the time he worked for them, was 18. His job was to spruce up the marquee while others worked on the bathrooms, the windows, and the ticket booth that protruded from the entryway, as seen in the picture below. He painted the inside of the letters that spelled "World" with yellow and the outside with red. Unfortunately, while working, he accidentally tipped a bucket of yellow paint off the ladder onto the sidewalk below. Several years later, Marlin worked there again, but this time he was part of the crew that erected the center wall dividing the auditorium. (At left, courtesy of Marlin Heiden; below, the *Kearney Hub*.)

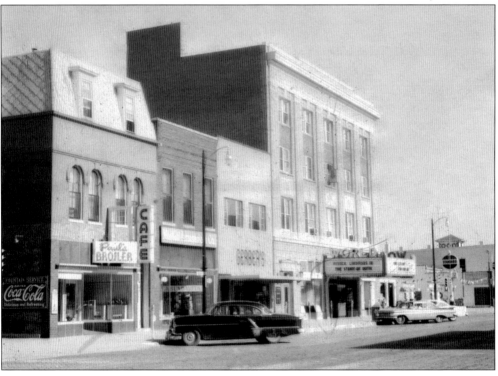

Going to the movies at the World on Saturday mornings in the early 1950s was important to Dave Mattson. The youngster liked to go see the Westerns, but his ability to do this depended on the bounty he could collect around town. For a handful of years while he was a kid, Dave would scavenge the streets and alleys of Kearney looking for discarded pop bottles that he would exchange for 2¢ a piece at Sherard's Grocery. A total of 14¢ was required to get a ticket, and anything more than that bought a snack or a drink. His heroes were Roy Rogers, Gene Autry, and Hopalong Cassidy, but he also enjoyed films with Lash LaRue, whose ability to bring down villains with his 18-foot-long bullwhip made him unique among the cowboy stars of the day. Serials, usually shown before the main feature, were effective at increasing his desire to attend because he wanted to see how the story, drawn out over several weeks, ended. Here is Dave during his bottle-collecting days. (Courtesy of Dave Mattson.)

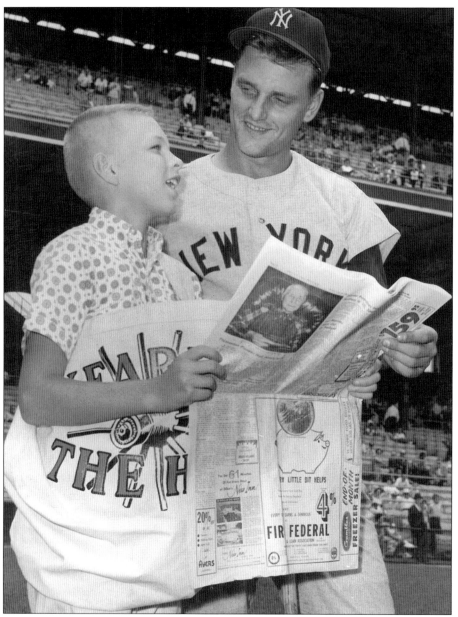

Clinton "Smitty" Smestad was the World's manager from 1953 to 1965 and had been managing a movie house in Boone, Iowa, before moving west. His son Sam Smestad, who was three when the family arrived in Kearney, said his father had a strong work ethic and high ideals. Daughter Mary, four years older than her brother, said Clinton started his career in theaters as a teen, always wore a suit to work, and was meticulous about how the World looked. Both agreed that growing up during the Depression and five years of World War II Army combat service in Europe and northern Africa shaped Clinton's personality and expectations. In 1958, the World's films were delivered by truck and sometimes these were delayed. When this happened, Smitty and his two kids would make what were long, slow drives to Holdrege or Hastings theaters to pick up or drop off what the truck did not. Seen here in 1962 with New York Yankee Roger Maris is Sam Smestad sporting his *Kearney Hub* newspaper bag. (Courtesy of Molly and Tyler Smestad.)

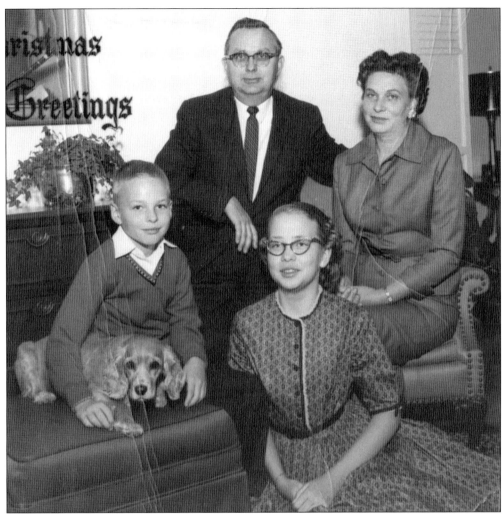

Life was different when the Smestads grew up and Kearney seemed "a lot like Mayberry," according to Sam. Letting youngsters go alone to a movie at the World was common, and parents did not have any reason to worry about their children. He added that on any given Saturday morning, the theater would "be packed with screaming, excited kids." Mary said that standards for acceptable behavior were much different then, too. When *Love Me Tender* with Elvis Presley was scheduled to be shown at the World on December 1, 1956, promotional materials, including an eight-foot-tall poster of the star, were shipped ahead of time. Manager Clinton Smestad was opening boxes the items came in with a sharp knife and cut himself, requiring a visit to a physician. Mary said the doctor was "appalled to learn from Clinton that photos of that scoundrel Elvis were going to be circulated at the theater." Presley's performances were considered too sexually provocative by many adults at the time. Shown here from left to right are Sam, Clinton, Mary, and Ruth Smestad. (Courtesy of Mary Smestad Krecek.)

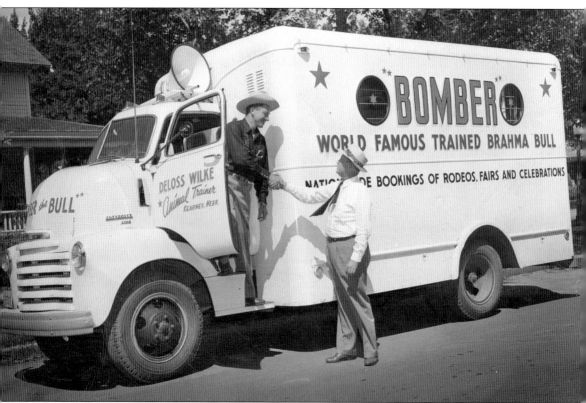

Mary Krecek remembers seeing Chuck Eisenmann and his dog London in her father's office at the World around 1957. Chuck had a long history as a pitcher with professional baseball organizations and was with the Kearney Irishmen for two seasons but left the sport because he was also an extraordinarily accomplished teacher of German Shepherds. Eisenmann's favorite of the many he had was probably London. The dog reportedly could find objects Chuck spelled for him, such as "h-a-t" and locate an individual in a group when his master described the person by age, gender, and attire. London was later featured in the films *The Littlest Hobo* in 1958 and *My Dog Buddy* in 1960 as well as a 1963 television series. A few past patrons and former employees believe Chuck and London appeared at the World in the late 1950s or early 1960s. The two performed at the Fort on August 20, 1958, according to an ad in the *Kearney Hub*. Seen here are DeLoss Wilke and the van he used to transport Bomber and Golden Spike (see page 52). (Courtesy of the Randolph Family.)

WARNER BROS. PRESENT

"Mister Roberts"

CINEMASCOPE — WARNERCOLOR · STEREOPHONIC SOUND

STARRING HENRY **FONDA** · JAMES **CAGNEY** — WILLIAM **POWELL** · JACK **LEMMON**

Also starring BETSY PALMER · WARD BOND · PHIL CAREY

Screen Play by FRANK NUGENT and JOSHUA LOGAN · Based on the play by THOMAS HEGGEN and JOSHUA LOGAN · PRODUCED BY LELAND HAYWARD · MUSIC COMPOSED AND CONDUCTED BY FRANZ WAXMAN · Directed by JOHN FORD and MERVYN LeROY

SALESMAN Park Dahlke BRANCH

SCHEDULE—EIGHTEENTH: The following Schedule and all of the written and printed parts thereof are a part of this license:

SCHEDULE

CONTRACT NUMBER D9047

THEATRE	EXHIBITOR	LOCATION OF THEATRE
Pix	Betty Noreen	Drummond Mont

TITLE OR DESCRIPTION OF PICTURE	Release No.	No. of Consecutive Days	Days of Week	FIXED RENTAL	SHARING TERMS GUARANTEE	PERCENTAGE	No. of Days	RENTAL	H.O. USE ONLY Not a Part of Schedule
"Mister Roberts" CINEMASCOPE AND WARNERCOLOR	418	✓	5/5			50%	7	2²⁵	

ADDITIONAL TERMS: APP.

There was no local control over popular movies scheduled at the World. The corporation that owned it would bid against other chain or locally owned theaters to get films from distributors such as Columbia Pictures and Fox Film Corporation. The first offer was typically made to the most profitable facility in town for a percentage of ticket sales over a specified number of weeks. Then, the distributor would go to other local houses to see if they would pay higher percentages. Although not for Kearney, these invoices illustrate the point. On one, the fee was 50 percent of ticket sales and the other required $25 per showing. For hugely popular movies, a distributor could demand 100 percent or more of ticket sales. In such situations, a theater manager's only avenue for paying staff, rent, and utilities would be concession sales. (Courtesy of Larry Karstens.)

A conversation between Marilyn Jones and World theater manager Ray Langfit at an American Legion bingo night in 1965 opened the door to opportunity for a teenager. Marilyn was 15-year-old Wally Helton's mother, and later that evening, she told him Langfit had a job for him if he would complete an employment application. Wally worked for the man for a few years taking tickets, changing the marquee, and working in the projection booth and admits the theater business "got into his blood." By 1974, he had earned his degree and had gravitated back into the field as a manager trainee with AMC Theatres, where he stayed for more than 20 years in a variety of managerial capacities. After that, he was employed by Mann Theatres in Hollywood, then United Artists Theatres in Denver, and he now works at Cinemark's world headquarters in Texas. Helton says the World sculpted him for the career he still is passionate about, even after three decades. Shown here around 1968 are World employees, from left to right, Mike Loveless, Wally Helton, and Joe Green. (Courtesy of Jackie Schutt.)

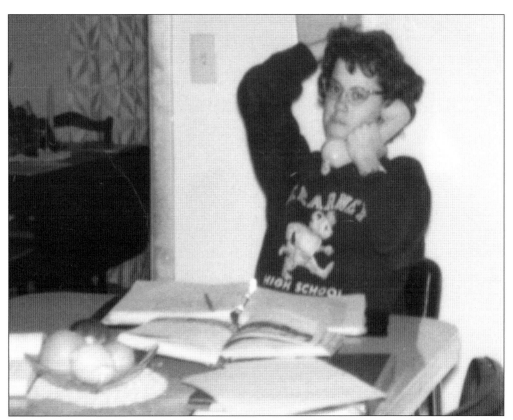

In 1965, Debby Kaufman Owings was 16 years old and worked at the World Theatre selling popcorn and candy. She recalls that the customers then were mostly college students, high school students, and young couples. She still remembers, watching through the theater's glass entryway, wave after wave of cars that slowly paraded past the World on Central Avenue. The young people that were cruising the town's main artery in their vehicles would return again every few minutes only to make another four-block journey. Debby is seen above around the time she worked in the concessions stand at the World, and below is part of a 1964 homecoming parade. The film on the World's marquee is *Robin and the 7 Hoods*. (Above, courtesy of Debby Kaufman Owings; below, the Buffalo County Historical Society.)

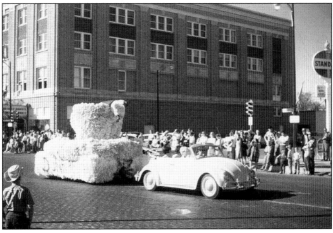

These sharply dressed young men from Kearney made up the Sunny Funny Company, a band popular in the region during the latter part of the 1960s. World Theatre manager Ray Langfit regularly allowed the band members to use the World's stage to practice after evening showings, which was a real benefit as it enabled them to set up their equipment and perform in a real venue rather than having to squeeze into a basement or garage and anger the neighbors with sounds from their keyboards, drums, and guitars. Langfit also wanted to get kids into the theater, so he asked the musicians to play on stage one Saturday morning before a movie. Their repertoire included plenty of Top 40 hits, and they were particularly accomplished at playing tunes by the Beatles, the Moody Blues, and the Rolling Stones. Wally Helton remembers that the place was about half full when they started and that the youngsters loved the show. From left to right are Mike Loveless, Rick Houchin, Richard Albrecht, Helton, and Al Paez. (Courtesy of Wally Helton.)

Richard Albrecht was 16 when Vietnam was the nightly news, Twiggy was a household name, and gasoline was 35¢ a gallon. He was at the World one evening and bought a big, cold soft drink to consume while watching the show in the balcony with buddies. Once upstairs, he placed his beverage on the ledge overlooking the auditorium and put his "dogs" up. His man-sized feet, nearly impossible to control at that young age, knocked the large soda over the edge of the balcony. A fuming cowboy with short-cropped hair sporting a very soggy Western-style shirt with pearl buttons immediately appeared upstairs next to him. Richard believed the man was intent on launching him on a flight path similar to the cup's, but his repeated apologies averted carnage. Richard is on the left about the time of the incident. (Courtesy of Richard Albrecht.)

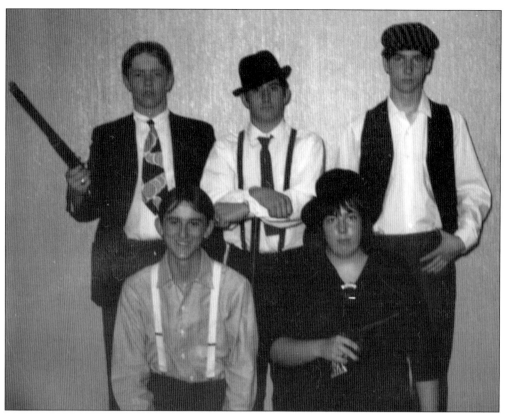

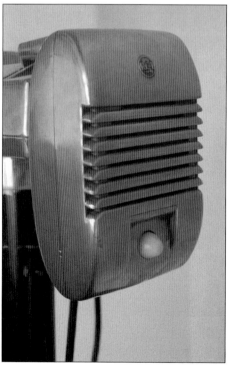

These young people worked at the World and the Kearney Drive-in and were recruited to pose for publicity photographs for a film screened at the outdoor theater starting on May 21, 1970. The flick, *Bloody Mama*, featured Shelley Winters as a twisted "Ma" Barker and her equally skewed sons as played by Robert DeNiro, Robert Walden, Don Stroud, and Clint Kimbrough. The photograph above of the teens dressed to resemble the movie's characters was snapped in the lobby of the World. From left to right are (front row) Joe Schutt and Vicki Mullen; (back row) Ron Osgood, Randy Seward, and Mike Geiger. According to Joe, "We thought of ourselves as family, and we didn't consider it 'employment' but a time to get together with friends to have fun." (Above, courtesy of Joe Schutt; at left, Bill Sinnard.)

Stan Bigg wanted his daughter's birthday party to be memorable, so he rented the World Theatre for a few hours in November 1972. Stephanie, the short one with the scarf and sunglasses, invited her entire kindergarten class, plus a few other little pals, to enjoy a movie presented just for them in the huge auditorium. She remembers it was an event that was scheduled on a weekday afternoon after school and that there were World staffers in the concessions area serving up popcorn and candy, that dad had paid for, to the 25 or 30 kiddies there that day. Stephanie said she doesn't recall what film was shown, however, she "had a great time" and the memory of that day is still very special to her. The picture, with Sue Bigg on the left and Julia Davidson behind the counter, was taken in Davidson's Jewelry, which, by this time, occupied the space next to the World where Gerber's Sweet Shop once had been. (Courtesy of Stan and Sue Bigg.)

The Kearney Daily Hub

COOKING SCHOOL

AND

HOMECRAFTERS INSTITUTE

PROGRAM OF MRS. DOROTHY AYERS LOUDON

WORLD THEATRE

Program for Wednesday Morning

✦ ✦ ✦

Jackie Schutt, a World employee for 42 years, often worked late on Thursdays, so she regularly took her toddler Mikki on those nights. One time, the child slipped loose in the lobby and headed for the auditorium entry. The three-year-old, aided by the slanted floor, was a step faster than mom; the pursuit did not go unobserved. Jackie made a couple of unsuccessful grabs for the child, and the laughter in the crowded house increased as did mom's embarrassment as they got closer to the stage. Above is an image from World manager Ray Langfit's 1973 retirement dinner, and below is part of a September 1940 cooking school program. (Above, courtesy of Joe Schutt; below, Waylon M. Kearney.)

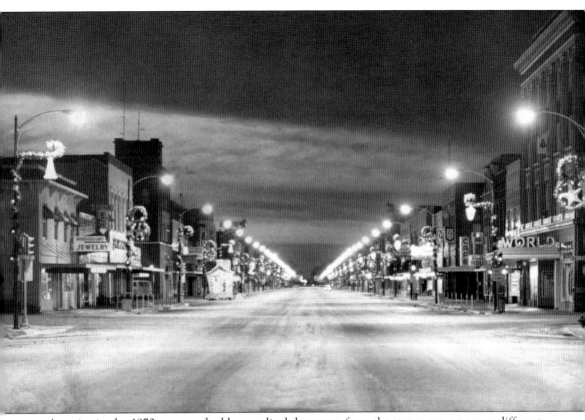

America in the 1970s was marked by a radical departure from the status quo on many different levels and included a distrust of government, the growth of feminism and narcissism, increases in drug use and crime, heightened concerns for the environment, and other issues. A revolution occurred then, too, regarding practices and beliefs pertaining to sex and sexuality. Kearney was not immune to what was happening, and as such, the World was not either. For a time between December 1975 and May 1976, at least four X-rated films were shown at the theater. These movies were typically scheduled once a month and always very late in the evening. The projectionist who worked there at the time, Joe Green, said these "packed the house." He added that audience members present for those showings were not from just a single demographic but rather were young and old, male and female. Green indicated that he thought the city fathers frowned upon the practice of providing adult entertainment there, so it was eliminated shortly after it started. (Courtesy of the Buffalo County Historical Society.)

Having a pal with connections was beneficial, even at the age of seven. According to Kama Ogden, she and her equally young friend, Mikki Schutt, whose mother worked at the World, spent a lot of time there and got to do things others did not. The girls sat in the balcony even though it was normally closed to others, and for them, this was the best place in the entire theater to be. Kama recalled that the two did some unsupervised exploring one day and ended up behind the screen. Even though they were young, both believed the dusty stage they discovered was "cool and magical," and it gave them the feeling that lots had happened there over the years. Kama was also curious about the people who had walked on that same wooden floor and wondered what it would have been like to see real theater there. Here is Kama on the left and Mikki on the right around the time they did their backstage investigating at the World. (Courtesy of Mrs. Mikki Schutt Cosson.)

These four celebrating a birthday at the World are, from left to right, Tammy Morgan, JacE Coslor, Kristin Richter, and Xavier Chavez. At the time, JacE was a box office employee at the theater, and her responsibility was to sell tickets and produce the nightly sales report. It was common for a representative from the distributor that sent a first-run movie to call JacE and box office employees at other movie houses after each night's last movie had begun to determine exactly how many tickets had been sold that evening. This was done to track revenue generated by the film. Furthermore, the amount a studio charged a theater to have and show one of its movies was based on anticipated demand; the bigger the expected audience, the higher the rental cost to have the film. A first-run movie is one that has just recently been released and never been in a theater before, while a second-run movie is one that had been in movie houses sometime in the past and is making the circuit again. (Courtesy of Jackie Schutt.)

Jackie Schutt said the theater's manager, Dick Smith, was often reluctant to hire high school students. His reasons for not employing many young people are easily understood. The showing of R-rated movies at the World was a financial necessity, as G, PG, and PG-13 movies did not attract large audiences with significant disposable income for concessions as one with more mature themes. As such, a young employee might have been exposed to adult content being shown in the auditorium. Secondly, an underage box office employee might have been put in an awkward position where he or she would have to authenticate the age of a ticket buyer wishing to view a restricted movie by requesting identification. (Above, courtesy of Ladies with Hattitude Red Hat Society, photograph provided by Kathy Hoffman, below; Cinema Entertainment Corporation.)

Xavier Chavez started as a projectionist at the World when a friend left his job there. When Chavez first learned the trade, one needed a broad skill set to keep the equipment functioning. For example, two carbon arc projectors were used, and these produced illumination for displaying film images onto the screen by allowing electrical current to jump across the tips of two internal carbon rods. The rod ends glowed and produced very intense light, but this arcing also required near-constant adjustment of the gap between the tips and replacement of the rods every hour as they burned away. The burning rods also produced residue that collected on the mirror positioned behind them, which reflected light forward through the lamp house and, ultimately, the lens. The mirror needed regular cleaning as a result. Finally, the films that Chavez showed early in his career arrived on reels that needed to be changed every 20 minutes, requiring him to show a complete movie by alternating between two projectors three times each hour without distracting viewers. (Courtesy of Fort Theatre Dentistry.)

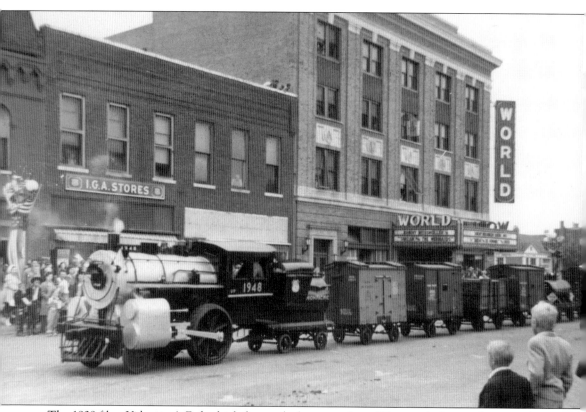

The 1939 film, *Kidnapper's Foil*, which featured a large number of Kearney kids, was shown at the World again on June 27, 1973, as part of the city's centennial celebration. Jennifer Harvey saw it then as a 10-year-old. She had not gone to the theater that day to see it, but she was there for the feature *Ma and Pa Kettle Go to Town* and, apparently, so were a lot of others, as she remembers the theater being filled to capacity. Jennifer said that the youngsters in the film were dressed like famous child actors and actresses she had seen in other productions and that there may have even been the iconic white dog with a black spot over one eye. She said seeing *Kidnapper's Foil* was profoundly confusing for her because while the performers were costumed like professionals, they were obviously not trained and the story unfolded at the fountain and open-air theater at Harmon Park. Shown here is another image from Kearney's 1948 Diamond Jubilee parade. (Courtesy of Harold and Inez Albrecht.)

In the mid-1970s, young Valerie Erpelding would meet her cousin midway between their homes on the way to an occasional Wednesday morning film at the World. Before entering, they would make a stop at the candy counter in Baumgartner's Variety Store, now Yanda's. Val recalls that it cost 50¢ to see the feature and 25¢ each for soft drinks and popcorn. The first movie she ever saw in a theater was *Digby* at the World in 1974, and just as memorable for her was seeing the original *Star Wars* there in 1977. On the left is nine-year-old Val, and on the right is her cousin Deb. Below, in front at Kearney's 1948 Diamond Jubilee, is parade marshal Brig. Gen. Guy Henninger of the Nebraska National Guard. (At right, courtesy of Valerie Erpelding; below, Harold and Inez Albrecht.)

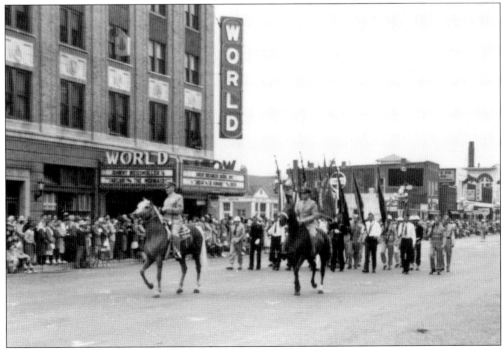

Few people can say that they actually grew up in a movie theater, but Erica Smith Kotschwar can legitimately make that claim. Her father, Dick Smith, became the manager at the World in 1973, just two years before she was born. She recalled taking friends like Cari Keller Walters on tours around the place, seeing the balcony and dressing rooms, and exploring the stage area behind the screen. There were some places that, as a very young child, she thought were "kind of scary," such as the boiler room in the basement, which she had convinced herself was haunted. She watched many films there and generally chose the front row over other spaces since it was considered "the cool place to sit." One of the most vivid memories she has of her time there was when *Star Wars: Return of the Jedi* premiered in 1983. According to Erica, seen here that same year, "It was very busy and there were people everywhere." (Courtesy of Erica Smith Kotschwar.)

Ron Thomas, a student at Kearney State College in the early 1980s, met a coed named Donelle Kummer at a fraternity event, and at the end of the evening, he asked her if she wanted to see *Risky Business*, starring Tom Cruise and Rebecca De Mornay, at the World a few days later. She accepted his invitation. According to Ron, he typically did not ask for a second date if he was ever turned down for a first one, he just "tended to move on." Four years and several World Theatre dates later, Ron and Donelle, seen here, were married. The irony is that Donelle had a chemistry exam the next morning and decided the afternoon of the show that studying was more important than going with Ron, so she called and cancelled. A short time later, Donelle's roommate succeeded in convincing her that there was enough time to see the film and return home afterwards for more test preparation. After another phone call, the relationship that "almost never was" began at the World. (Courtesy of Ron and Donelle Thomas.)

News that the World Theatre would be divided into separate auditoriums was announced in the *Kearney Hub* on March 19, 1983. Manager Dick Smith said that each would have seating for 350 people and that the construction work would begin immediately. He claimed the reason for the remodeling was so that more first-run movies could be shown. The strategy was that in smaller venues, if an expensive blockbuster could be successfully bid for and then scheduled on a five-week minimum commitment, it would probably result in little, if any, profit. Its twin, however, could have several lower-cost second-run films during the same period that might produce income. While one theater might have lost money, movies in it would have enhanced the World's reputation of carrying hits. The second served to keep the operation afloat financially and provided consumers once-popular flicks that were proven performers. The promotional pins pictured here were shipped to theaters prior to a movie's arrival and were intended to be worn by film house staffers. Employees used them to decorate the Christmas tree in the World's lobby. (Courtesy of Joshua Ryan Henderson.)

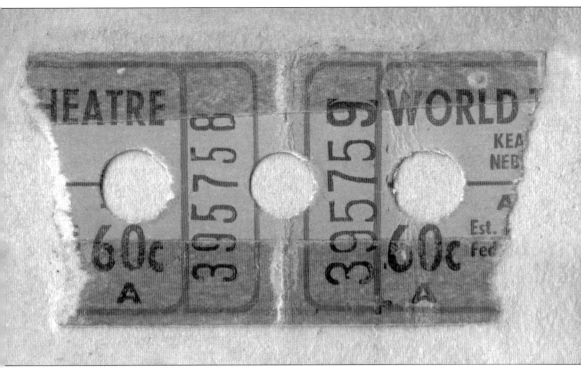

Three weeks later, the headline for the lead story on the front-page of the *Kearney Hub* was, "New $7.5-million Shopping Mall to Employ 300." On April 8, 1983, this news may have been welcome for shoppers, but for businesses in the downtown area, including the World, it also meant increased competition. According to Dick Smith, manager of the theater, leaders at Central States Theatre Corporation knew of the development plan prior to the announcement and were aware that a movie house was planned for the new facility even though none was shown in the drawings published in the *Hub*. It was their decision to preemptively "twin" the World Theatre in an effort to actually get first-run productions. It was also apparently meant to intimidate anyone thinking of constructing a movie house at the new mall. These ticket stubs were from the *Girls of Pleasure Island*, which was shown at the World on July 5, 1953. (Courtesy of and in loving memory of Moniema [Andresen] Niemeyer from her family.)

When asked what she learned during her time at the World, Valerie Erpelding replied, "Working there really taught me how to do math in my head." She started in 1984 and stayed throughout her four years as a college student. There was not a cash register in the concessions area where she worked, so she had to make quick calculations and do so accurately, not only to satisfy the buyer, but also to ensure that the money and inventory matched at the end of the day. It was common for customers to make large orders, especially if purchasing for several people, so the exercises in mathematics could be challenging. Seen at left is Val on her college graduation day in December 1988. (At left, courtesy of Valerie Erpelding; below, courtesy of and in loving memory of Moniema [Andresen] Niemeyer from her family.)

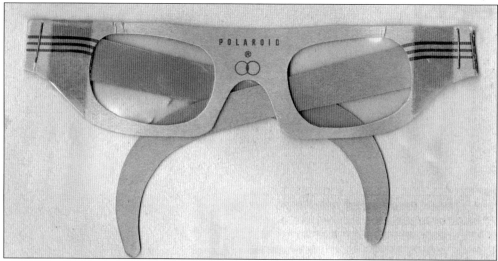

Thirteen-year-old Tessa Roberts's parents were divorced and she lived near Blue Hill with her mother, but every other weekend in 1995, she was in Kearney to visit her father. Additionally, the custody agreement stipulated that she was to spend three continuous weeks with her father during the summers. Not being a local kid, she didn't have any friends in Kearney and did not want to stay in her dad's trailer all day. She could have gone to the mall, which attracted lots of young people, but it was crowded and she wanted solitude. She discovered the World. Tessa said she went there about 30 times that summer and, because the matinee did not change very often, she watched some of the same movies over and over. Her impression was that the carpets were worn and the seats were horrible. She said, "It was run down, but I was comfortable there because my life seemed run down at that time, too." For Tessa, shown here, the World was her haven during the summer of 1995. (Courtesy of Katherine Stoner.)

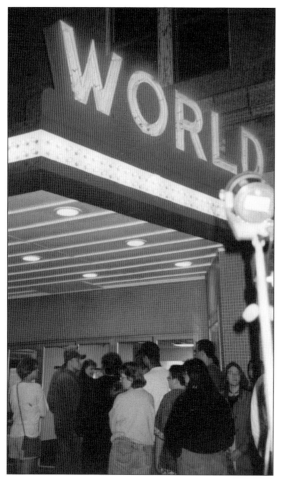

In spite of originating more than three decades earlier, the six-episode *Star Wars* series was still the country's greatest film franchise in 2010 based on domestic box office receipts, according to Tim Dirks at www.filmsite.org. The twin trilogies altogether generated about $2 billion dollars in theater tickets sales in the United States and twice that amount worldwide. Episode I in the series' prequel, *Star Wars: the Phantom Menace*, played at the World starting May 19, 1999, and the image at left shows a portion of the crowd that had assembled early to get tickets for that night's premiere. Below, a reporter from KHGI-TV interviews an anxious fan on the same evening. (At left, courtesy of the Widger family; below, Kaye Linn Albrecht.)

Star Wars Director George Lucas introduced viewers to AT-ATs, Tatooine, and Wookiees. According to the *Kearney Hub*, on May 19, 1999, *Star Wars: the Phantom Menace* showed at the World at 12:01 a.m. that morning, and Sam Widger arrived 15 hours early with his lunch and cooler of Diet Mountain Dew to stake out his spot in front of the theater. It had been 16 years since the last film in the franchise had been released, so those in the long line that developed were excited. Some were having lightsaber duels, a few were in costume, and many were ordering pizza to be delivered. Above is Sam with his hands on his wife Michelle's shoulders. Below, fans are watching a live local news report that night in front of the World. (Above, courtesy of the Widger family; below, Kaye Linn Albrecht.)

One evening in 2000 while working at the World, projectionist Colin Watley started the *Cider House Rules* at its scheduled time and then went downstairs to assist others selling concessions and tickets. At the end of the film, when the crowd started exiting through the lobby, a coworker recognized a familiar face, but it was not one they had seen in Kearney before. Excited, Colin stopped the tall, oddly dressed fellow and asked for an autograph. Hunter "Patch" Adams declined, but said, "If you e-mail me, we can be friends." During the brief conversation that followed, they learned he was in town speaking at a conference and decided to take in that night's feature at the World with his girlfriend. Before departing, Adams gave Colin a pamphlet about "ways to help people" and agreed to pose with the young man and his friends for a photograph. Robin Williams portrayed Adams, the physician and social activist, in the 1998 movie *Patch Adams*. From left to right are Colin Watley, Adams, Amanda Barp, and Shawn Jensen. (Courtesy of the Watley family.)

According to the *Antelope*, the UNK student newspaper, *Rebel Without a Cause* was shown at the World on October 5, 2000. Organized by Dr. Sam Umland of the university's Department of English, the event was meant to commemorate the 45th anniversaries of James Dean's death and the release of the movie. Umland wanted his History of the Motion Picture class and others to see the production on the big screen as it was intended. It also enabled viewers to appreciate Dean's dynamism. Frank Mazzola, who costarred as Crunch in the film, attended the screening and spent time addressing questions posed by the approximately 200 attendees. Above are Mazzola and his family. Below, Mazzola's signature as penned in the margin of the event's program for a student. (Above, courtesy of Sam and Rebecca Umland; below, Duster Ellis.)

e in the arts. After graduating from the prestigious
therine danced professionally with THE NATIONAL
uhn and Alexander Grant. After four seasons and
to the precarious world of commercial modeling and
d later Wilhelmina Models, her fashion career took
hlights include a 2-year contract with GIORGIO OF
print and commercial campaign for DIET COKE,
r LEAN CUISINE, CERTS, MITSUBISHI, PEOPLE
erine's notable work as an actress includes Milos
ard winning National Film Board Documentary,
do's Civic Theater production of DANGEROUS
ABYLON 5, SUPER FORCE, and SWAMP THING.
ience and her natural instinct in front of the camera
creenplay writing. Her credits include Associate
l's WILD SIDE, and Martin Donovan's SOMEBODY
hmell film, credits Catherine as Associate Producer
GDAR'S SECRET and THE PIER, are presently in

To my very best, Frank Mazzola "Crunch" 10/5/00

Star Wars: Attack of the Clones was shown at the World beginning on May 16, 2002. John Albrecht, then 15 years old, is seen above, standing beside the striped chair. He said that he thinks he skipped school that cold day in May to get in line about 10 hours before the showing. He said some of the fans sitting in lawn chairs and on the sidewalk had laptops and were watching earlier movies from the franchise to get primed for that evening's film. He said going to movies there over the years with his father helped shape his decision to work in filmmaking. After earning his degree in the field, he relocated to Los Angeles, the epicenter of the industry, to begin his career. (Courtesy of Kaye Linn Albrecht.)

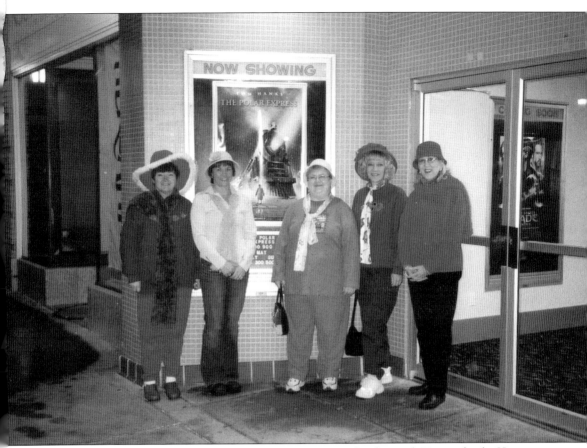

On a cold, foggy December evening in 2004, a contingent of Ladies with Hattitude, the Kearney chapter of the Red Hat Society, assembled for their monthly celebration of womanhood, maturity, and comradeship. The original plan included a short drive to another community to enjoy an outdoor Christmas pageant, so plenty of sweet treats and hot chocolate had been prepared earlier to steel them against the elements. Unfortunately, the weather made such an excursion treacherous, and the members chose to see *Polar Express* at the World instead. Jackie Schutt, an employee of the theater and a member of the group, persuaded the manager to allow them exclusive use of the balcony, and he let them carry in their treats provided they shared with World employees. The deal was struck, and the ladies were thrilled with a grand viewpoint of the animated film that seemed to be presented just for them. From left to right are Diana Parker, Jacque Burns, Kathy Hoffman, Darla Wright-Covert, and Jackie Schutt. (Courtesy of Ladies with Hattitude Red Hat Society, photograph provided by Kathy Hoffman.)

Laura Snider, seen above, went to see Santa at the World in November 2005 with an important request. When she arrived that evening to see Mr. Claus, the lobby was filled to capacity and youngsters were lined up out the doors; she waited patiently as the queue shortened one child at a time. Laura liked to practice playing the piano, and whistling while finding a tune's notes on the keyboard helped her to play the instrument even better. Unfortunately, she lost her front teeth, and this had completely affected her music. Her request? You guessed it. Santa eventually delivered as promised. Below are tickets from *I Love Melvin*, which showed at the World on May 31, 1953. (Above, courtesy of the Snider family; below, courtesy of and in loving memory of Moniema [Andresen] Niemeyer from her family.)

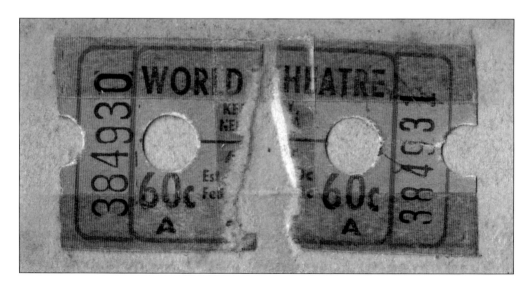

Joshua Ryan Henderson learned to be a projectionist at the age of 20 at the Fox in McCook, Nebraska, which had been a property in the World Theatres chain in the early 1900s. From 2006 to 2008, he was in Kearney at the World selling concessions and preparing films for showing using platter-style projectors rather than the older carbon arc machines. With these newer ones, the multiple film reels that composed a two-hour movie were spliced together to create one long strip. The reels were stacked horizontally so as one platter emptied, it pulled the film from the next one. This system eliminated the need for the projectionist to switch from projector to projector throughout a production. On a typical night, it took him about 30 minutes to splice the entire film, and then he would return to the lobby to remotely start the projector, take tickets, and route patrons to the correct theater. Joshua is shown here at a 2006 wedding reception with his father. (Courtesy of Joshua Ryan Henderson.)

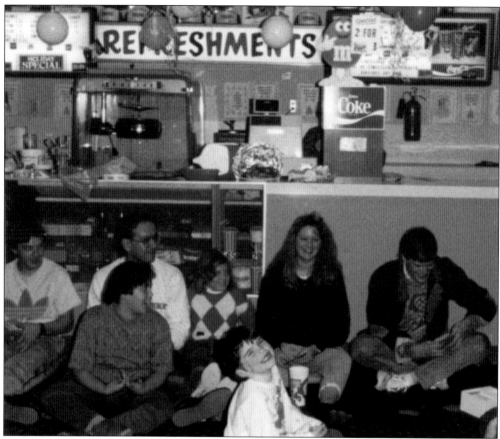

The holiday season at the theater was a very memorable time for Joshua Ryan Henderson, who worked there two years before it closed in 2008. On Saturdays, Santa Claus would be there talking with little ones, hearing what was on their wish lists, and handing out candy canes. There was usually a movie shown for free or at a very low price, and this was often the prior year's smash kid-flick. Joshua liked that lots of people would be downtown walking by the theater, carrying bags, looking in widows, and visiting with friends, which all added to the cheerful feeling in the air. The image above, captured in the theater's lobby, is from a 1990 Christmas party for World employees. Below is a pair of glasses from the 2003 film, *Spy Kids 3D: Game Over*. (Courtesy of Xavier A. Chavez.)

In June 2010, *Ghost Hunting 101*, taught by Bill Sinnard and Jacob Sikes of Midwest Paranormal Investigators, was offered through Central Community College in Kearney. On the course's final night, Deanna Jesse, Dorothy Miller, and several others met at the World with flashlights and heat sensors. Bill said he and Jacob chose the theater because former employees told them they had heard voices and footsteps in the building in years past. Recalling that June evening, Deanna chose to explore the lower level first with her partners to "get it over with" because it was creepy. Halloween props such as doll heads and arms were stacked in dark basement rooms. After moving upstairs to the dressing rooms, projection booth, and the stage, where previous investigators noted unusual phenomena, they were summoned back underground where their classmates were. (Courtesy of Bill Sinnard.)

On that June 2010 evening, when Deanna and Dorothy entered the basement again from a second stairway near their peers, they could see two points of light in front of the group, the larger the size of a quarter, moving "like Tinker Bell" in the stairwell. Dorothy inched closer and saw when the lights moved they left trails like "a Fourth of July sparkler." One woman, who was within a few feet of the apparitions and had experience on other investigations, was directing questions to the lights, which would glow brighter, they believed, to answer affirmatively after not responding to several other inquiries. Deanna, Dorothy, and Bill said that through several minutes of questioning, one seemed to indicate it was a young boy and the other a young girl. They described the lights as "innocent and non-threatening." All three said that while they were scared when starting the adventure that night, during the stairway encounter they felt "comforted," "safe," and "happy." This picture shows the spot where the group saw the lights hovering. (Courtesy of Deanna Jesse.)

Four

THE DEMISE
AND RESURRECTION
OF THE WORLD

Over time, the habit for many of regularly going to the theater diminished as other media such as magazines, newspapers, radio, and television grew in number, popularity, accessibility, and affordability. Going to see a film became, for many, a "special event," such as going on a first date or to see a big new release rather than attending as part of one's weekly routine. Also, sectors within the viewing public had become increasingly concerned about film content and the impact language and imagery could ultimately have on impressionable minds. These factors impacted movie house revenues, which in turn influenced the quality and popularity of films that were shown, the size of theater staffs, the upkeep and modernization of facilities, hours of operation, amount of on-stage entertainment that preceded or followed flicks, and other facets of the business. Additionally, the costs of producing films increased due to salary demands by stars and labor unions and expenses associated with creating bigger, more thrilling, and technologically sophisticated films. Movie distributors then began to demand more from theater operators in response, resulting in higher prices at the box office.

A *Kearney Hub* writer appropriately asked on January 23, 2007, "How many movie theaters can survive in Kearney?" Executives from Cinema Entertainment Corporation, the Minnesota-based parent of the World and the Kearney Drive-in, had just announced plans to build a new eight-screen theater next to Kearney's Hilltop Mall. This was in response to a Memphis developer's November 2006 news about constructing a theater in south Kearney. Carmike Cinemas was still operating the Hilltop 4 theaters and conceivably would have continued doing so, even while CEC's leaders were putting up their new place just across the parking lot. The likelihood the region could support 23 screens was slim, yet CEC broke ground for its new Hilltop facility in April 2007, a short time after the out-of-state developer had started. (Above, courtesy of Joshua Ryan Henderson; below, Xavier A. Chavez.)

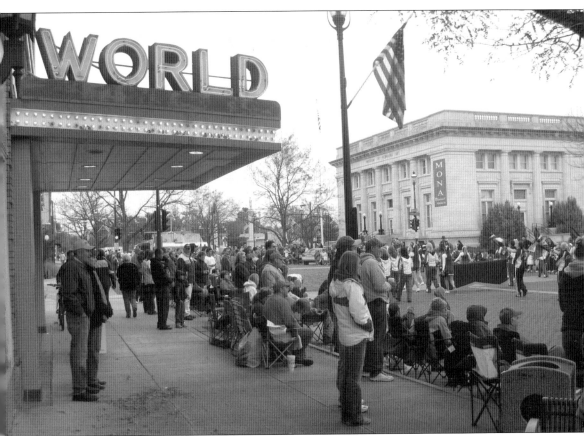

By late summer 2007 and after an investment of capital, Cinema Entertainment Corporation's work at the Hilltop Mall on the freestanding new theater had stopped. According to the *Kearney Hub* on August 2, the CEO of the company, which owned the mall and had partnered with CEC on the venture, said, "The other theater has more momentum . . . our project is on hold." In fact, the new venue near Interstate 80, Kearney Cinema 8, opened later that year on November 22. This newest entry had shaken up the market, and Carmike Cinema's lease to operate the Hilltop 4 at the mall ended the next spring. Its leaders chose not to renew it. In the April 28, 2008, *Kearney Hub*, their director of marketing said, "The theater was unproductive financially. It underperformed." There is little doubt that the Kearney Cinema 8 had siphoned ticket buyers away from Carmike Cinema's operation. (Courtesy of the World Theatre Foundation.)

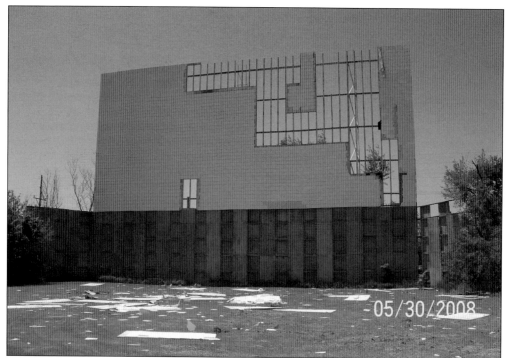

On May 29, 2008, a tornado severely damaged parts of the Kearney Drive-in, and afterward, the outlook for the venue was grim. Down to one functioning operation in town and apparently believing they could make the Hilltop 4 competitive, a Cinema Entertainment Corporation spokesperson announced five days later that they would begin operating the mall facility Carmike Cinema left. Aware there were still too many Kearney screens while probably trying to free up capital, the executive told the *Kearney Hub* that the World would close on June 5, 2008. The photograph above was taken on May 30, 2008, and shows the drive-in's essential feature. *A Place in the Sun* showed at the Kearney Drive-in on July 19, 1953, and this ticket is from that night. (Above, courtesy of Erica Smith Kotschwar; below courtesy of and in loving memory of Moniema [Andresen] Niemeyer from her family.)

On July 18, 2008, bulldozers began demolishing the 58-year-old Kearney Drive-in. The same day, the *Kearney Hub* reported that drive-in property owners Mike Kalb and Mark Benjamin of Kearney would not rebuild, and this decision terminated Cinema Entertainment Corporation's lease. Benjamin said, "The shortfall of insurance money versus the cost to replace the structure was insurmountable." In the 1950s, the Kearney Drive-in opened in March, attesting to its popularity before competition from other media. It became a Kearney Theatres property about August 29, 1953, after being purchased from Mearle and Betty Lewis. The *Kearney Hub* reported June 2, 2009, that CEC, which had owned the World and the Kearney Drive-in, was selling the Hilltop 4 theater to the owner of the new Kearney Cinema 8. This image shows scattered pieces of the drive-in's screen after the storm. (Courtesy of Erica Smith Kotschwar.)

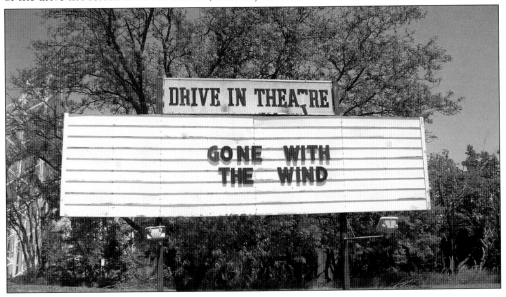

The theater on Central Avenue sat empty for about a year before a group of locals formed a nonprofit organization led by Hollywood screenwriter and Kearney native Jon Bokenkamp. On June 21, 2009, the *Kearney Hub* reported that the board of directors consisted of Brad Driml, Mark Loescher, Dr. Walter Martin, Jayne Meyer, Ben Rowe, Dan Speirs, Karla Steele, and Bokenkamp and that they intended to renovate and reopen the World. Rather than competing against larger houses with greater resources and attempting to secure first-run movies, the emphasis at the new World would be on providing a creative alternative. It would also serve as a meetinghouse, a location for fundraising events, a place for weddings, and a setting for parties. The grassroots effort to "Save the World" had officially begun. (Courtesy of the World Theatre Foundation.)

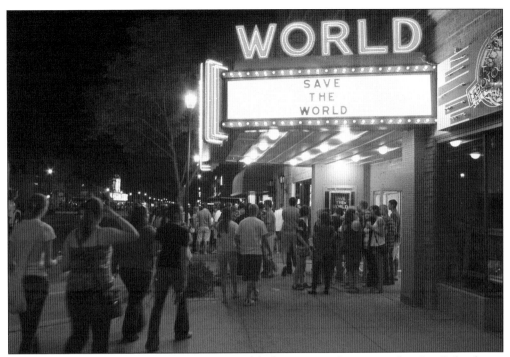

At a press conference on October 2, 2009, World Theatre Foundation president Jon Bokenkamp announced plans to revitalize the World Theatre; the fundraising goal was $150,000. By November 5, the foundation had raised $40,187. By December 3, more than $80,000 had been banked, and by January 6, 2010, interested individuals and organizations had committed $169,179. The second phase began immediately with a goal of $400,000, which was $231,000 over previous donations. According to the January 6 *Kearney Hub*, the new goal would result in funds for "pursuing grant opportunities, meeting with private donors, architectural and design work, heating and electrical updates, replacing the seats, and enhancing handicap accessibility." The building was entered on the National Registry of Historic Places, making it eligible for grants at the state and federal levels. (Above, courtesy of "the Chad;" below, the World Theatre Foundation.)

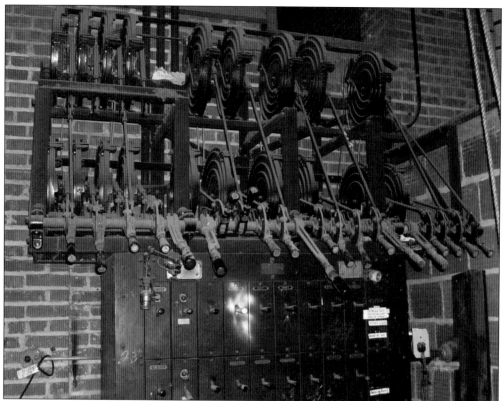

Foundation president Jon Bokenkamp said, "There was no one place to go to learn to renovate and restore a theater of this type." There was work that needed to be done immediately, but before any significant changes could be made, the structure needed to be evaluated by an architect and a mechanical engineer. For example, all of the electricity for the backstage area still made use of the original 1927 power panel, which looked like a movie prop from an old Frankenstein film. "We couldn't just call an electrician and ask for modifications to the system. It all had to be reworked. It was a big Rubik's Cube," said Bokenkamp. Seen above is the World's power panel, and below, a crowd gathered for an event in its lobby. (Above, courtesy of the World Theatre Foundation; below, Ben Rowe.)

Philip Cudaback, a Kearney native living in California, learned about the effort to "Save the World" from the online edition of the *Kearney Hub*. He had a great deal of experience designing theaters in the Midwest and on the West Coast. He was a cofounder of Lahaina Architects of San Diego, which developed new, modern theater complexes. He contacted Jon Bokenkamp to describe his expertise, and soon after, Cudaback was hired to turn the board members' vision of a renovation of a historical landmark into plans for the project. "His drawings and engineering notes made a complex project with no easily identified path to completion manageable with a tangible finish line," said Bokenkamp. Below, makeup is applied to a young person who worked at one of the World's on-site haunted house fundraising events. (Courtesy of the World Theatre Foundation.)

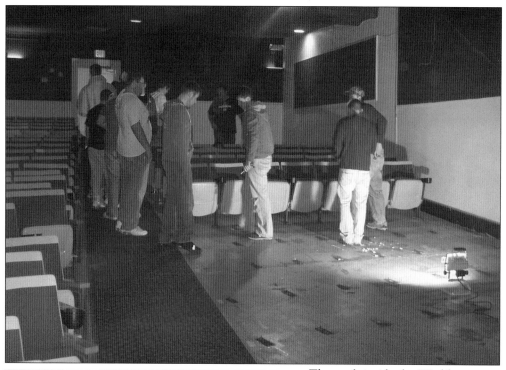

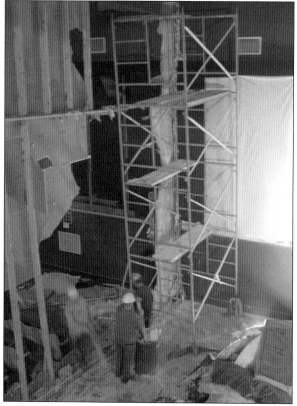

The work inside the World became a mix of restoration and renovation. Jon Bokenkamp felt it was important to uncover the structural character in the movie house, which required removing the center wall added in 1983. Early during this phase of the project, workmen started by removing a chunk of it near the front of the auditorium, creating a window-like opening into the other side, and Bokenkamp said that the moment he looked through, it "was exhilarating, a shot of adrenaline." During the three days it took to dismantle the partition, workers found that three layers of drywall had been applied to each side in an attempt to soundproof each theater. Above, seats are being removed for the workmen who later dismantled the dividing wall. (Above, courtesy of Bill Sinnard; at left, Jon Bokenkamp.)

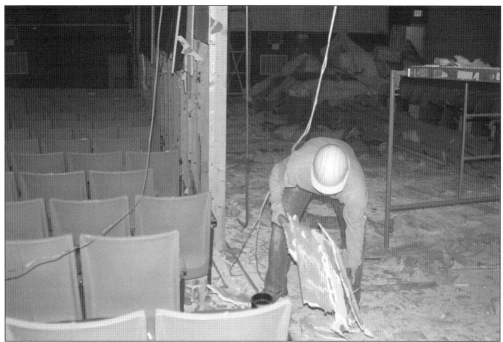

During the process of removing the two-story center wall, Bokenkamp discovered that when it was erected almost three decades earlier, the carpenters who did the work did not cut and gut architectural elements of the World to attach it in place. Rather, they carefully built around intricate plaster components, preserving its charm and traits for another generation. This resulted in fewer expenses for the foundation since these areas did not have to be recreated. More surprises came to light later when the organ lofts high up on the front wall on the left and right sides of the original stage were found concealed behind drywall. These were uncovered and were where the pipes for the original Marr & Colton had been mounted. (Above, courtesy of Jon Bokenkamp; below, Bill Sinnard.)

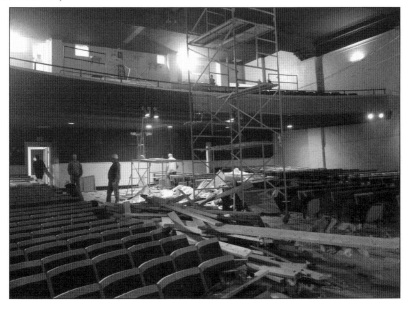

Architect Philip Cudaback said that uncovering the original characteristics of the theater during the restoration was the goal. He said it was built and designed to suit Nebraskans who chose simplicity and modesty over flashy. Original architectural embellishments such as columns, their capitals, and other decorative elements, which had all been whitewashed at some time in the past, were cleaned and highlighted by two artists who specialized in historical decorative painting. In the image at left, detailing is being performed on a section of column near the ceiling and next to the balcony. The image below shows acanthus leaves near the stage; the lighter portion would have been unnoticed and unappreciated, but the addition of the contrasting colors made them clearly discernible to anyone entering the area. (At left, courtesy of Jon Bokenkamp; below, the World Theatre Foundation.)

Some aspects of the facility had to be changed by design or out of necessity, and it was especially challenging for architect Philip Cudaback to fit modern requirements into an early 1900s building. His new designs, based on discussions with the board members, included enlarging the bathrooms and making them handicap accessible, improving the fire suppression system, and planning for the installation of modern heating and cooling systems. The stage, shown at right, was expanded forward into the auditorium, and its leading edge was slightly arced, giving it a more theatrical and attractive appearance. The lobby was returned to its original ceiling height, and some special features were added there, too. Cudaback said that the "concept was to create a 1930s or '40s club feel. Not glamorous but cool, fun, and happenin'." (Courtesy of Lahaina Architects, Philip Cudaback-partner.)

WOMEN'S RESTROOM PLAN

The World foundation members and the architect wanted to incorporate the concept of stadium-style seating, shown above, into the redesign. Above the fixed-seating in the lower portion of the auditorium, a stepped floor with four-foot-wide raised platforms replaced the simple inclined base. This technique made the auditorium ADA-compliant, provided excellent viewing areas at the mid- and top levels for all, including those with mobility challenges, and gave the space a slightly more contemporary feel. Architect Philip Cudaback indicated that accomplishing this was a simple task, but it was only possible because of the quality of the original design and integrity of the 1920s workmanship. Cudaback said, "We want the World to be here for the next hundred years and, fortunately, its bones are pretty strong." At left is a section of the redesigned concessions area. (Courtesy of Lahaina Architects, Philip Cudaback-partner.)

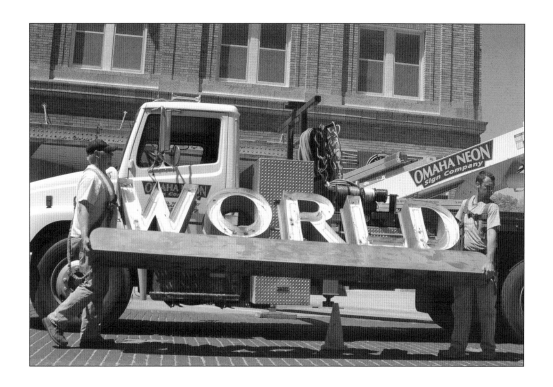

Outside of the building, some renovation and restoration work was undertaken. The aluminum lobby doors were replaced with an attractive wood entry, similar to the one used in 1927. The ticket booth was positioned outside between the new entry doors so as to allow more space in the lobby, and the original marble facing behind the outdoor poster cases was uncovered. The marquee was redesigned and reworked by Omaha Neon to make the front of the theater attractive and inviting. The sidewalk on the north side of the building was replaced because it sloped toward the building, causing rainwater to accumulate in the basement. Above, Omaha Neon employees are removing part of the marquee, and below is some of their proposed redesign of it. (Above, courtesy of Jon Bokenkamp; below, Omaha Neon Sign Co. Inc.)

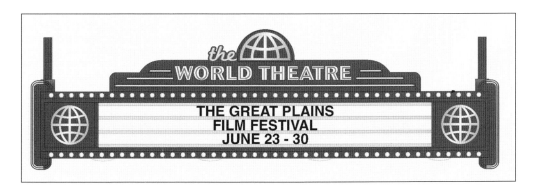

LOBBY ELEVATION - NORTH

For architect Philip Cudaback, the World project was a more personal assignment than others he had worked on around the country. He started going there to see movies when he was eight, and his mother used to drop him off with a few dollars to cover the cost of a ticket, a drink, and something to eat. In high school, he remembered sneaking into the balcony to covertly see films, and this adventure was all the more enjoyable if done with a good-looking girl. As Cudaback said, "The World was part of my life." He added that the restoration and remodel took longer than other similar endeavors but was worth the effort because he wanted to give back to the town where he grew up. (Above, courtesy of Lahaina Architects, Philip Cudaback-partner; below, the World Theatre Foundation.)

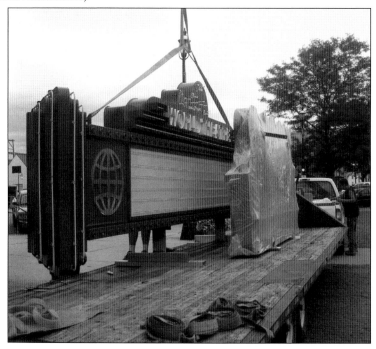

There was tremendous support for saving the World, and Bokenkamp said, "Everyone had a memory relating to the place. Tapping into people's nostalgia about it was the least difficult part." The numerous Facebook fans of the World wrote about their memories of seeing *Saturday Night Fever*, *Star Wars*, and *Bambi*. Others talked about going there as children, sitting in the balcony, and listening to other little ones screaming with excitement. Some mentioned that they worked there, as well as at the World's sister operation, the Kearney Drive-In, and their sadness when both eventually closed. Many immediately internalized the idea of showing older or independent films rather than current hits and suggested titles such as *Vertigo*, *The Blob*, *Ben Hur*, *How the West Was Won*, and *The Rocky Horror Picture Show*. (Courtesy of the World Theatre Foundation.)

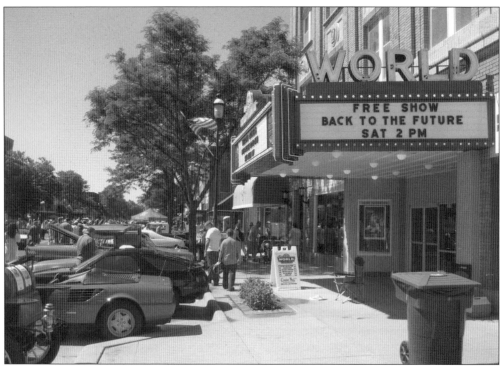

After discussions with architects, contractors, and engineers, several models regarding the final renovation were apparent by summer 2010. The World Theatre Foundation board members chose to reach for the highest rung; their vision was to raise $675,000. In June 2010, Gov. Dave Heineman assigned the project $300,000 in block grant funding available through the Department of Economic Development's Nebraska Tourism Development Initiative. These dollars were for ventures that "draw visitors from a distance because of their scenic, historic, cultural, heritage, scientific, educational, and/or recreational attributes." The Kearney City Council served as grantee for the award disbursed to the foundation, but the group had to raise $100,000 as a partial match, which they did in December 2010. The World Theatre Foundation also successfully met a $100,000 Peter Kiewit Foundation challenge grant. (Above, courtesy of Ben Rowe; below, Bill Sinnard.)

According to Jon Bokenkamp, fundraising took on a life of its own. It became necessary to hire professional grant writers to articulate the board's goals and to submit the lengthy applications on deadline. This necessitated finding writers, explaining the vision, and securing information needed by them. Another aspect of capital generation concerned award stipulations and how those affected fundraising goals. When some grantors provided funds for the project, the World's foundation was sometimes expected to generate a full or partial match of those dollars. The initial goal of $150,000, set October 2, 2009, was increased not only because of the tremendous response from supporters, but also because of such stipulations. According to Bokenkamp, fundraising "became a living and breathing entity." Below are participants of a video game fundraising event at the World Theatre. (At right, courtesy of Lahaina Architects, Philip Cudaback-partner; below, the World Theatre Foundation.)

MEN'S RESTROOM PLAN

In July 2010, the foundation's board members learned that $21,800 had been set aside for the World by the Kearney Downtown Improvement Board and the Kearney Area Community Foundation to construct the new ticket booth and move forward with renovations to the historical facade. The World's original 1927 Marr & Colton organ, sold at some point in the theater's history, returned home in February 2011. Jerry Kautz of Houston acquired it in Kansas in 1999 and had it in his residence for 12 years before learning of the renovation and selling it to the foundation. Above is the architect's plan for the renovated lobby, including the repositioning of the ticket booth out front. At left, ancient lobby floor tiles peek through from beneath carpeting and glue. (Above, courtesy of Lahaina Architects, Philip Cudaback-partner; at left, the World Theatre Foundation.)

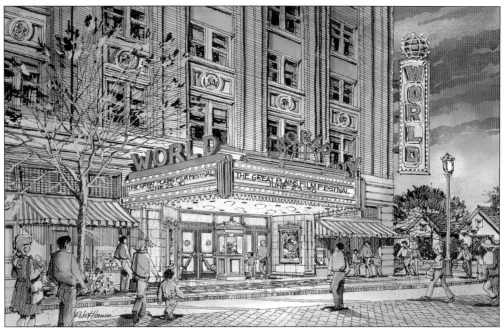

The World's foundation members have articulated a number of ideas that will make the theater an integral part of the community and central Nebraska once again. One possibility is the development of the Great Plains Film Festival, in conjunction with the Merryman Performing Arts Center and the Museum of Nebraska Art, that would attract films and filmmakers from around the globe. Another notion is to host a statewide student film festival that would be conducted in partnership with the Nebraska Department of Education and could attract participants and supporters from every school district in the state. This would culminate with an Oscars-like awards ceremony on the final day of the event. Below, the locations of the original lobby movie poster cases were revealed after removing a layer of drywall. (Above, courtesy of Robert Hanna; below, the World Theatre Foundation.)

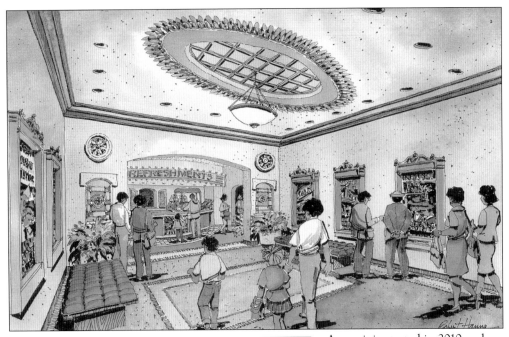

An activity tested in 2010 and proved promising was a Nebraska video game festival. The intent is to capitalize on the success of the earlier event, expand it, and attract more participants. The World's foundation members have considered hosting the tournament with a national organization such as the Global Gaming League or the Personal Computer Gamers Network League. This non-stop, 48-hour competition would end with an awards breakfast at the World. Three straight days of fun for those who are young at heart are apt words for describing Kid-a-Palooza. This will include *Looney Toons* shorts in the mornings, family films like *Shrek* for the matinees, Oscar-nominated Short Subjects films a bit later, and evening offerings such as the *Goonies*. (Above, courtesy of Robert Hanna; at left, World Theatre Foundation.)

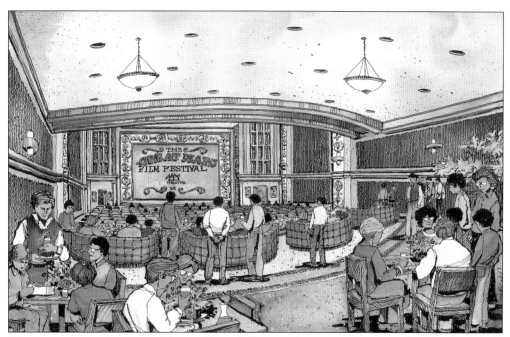

The acquisition of a state-of-the-art Digital Cinema Initiative camera will make the World much more than a film house and, in fact, enable it to serve more contemporary fare. With the DCI projector, it will be possible to project educational and cultural content onto the theater's screen and listen to the same on the auditorium's Dolby sound system. Possibilities include *Live from the Met* operas, educational *Technology, Entertainment, Design* presentations (or *TEDTalks*), and concerts. The 1927 structure could serve as a classroom again for Hollywood screenwriters visiting Kearney to describe how to produce materials for the entertainment industry and how to get them read by the right people. Writers of all ages would have the opportunity to pitch ideas and get feedback from working entertainment professionals. (Above, courtesy of Robert Hanna; below, the World Theatre Foundation.)

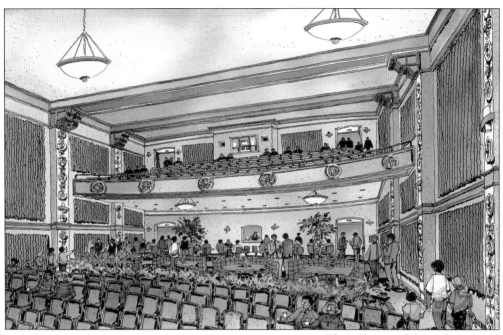

The redesign of the auditorium meant that a variety of activities or events could be held there that were not feasible before. These include weddings and receptions; closed-circuit athletic events; political rallies, fundraisers, and speeches; and live Academy Awards Oscar viewing parties replete with red carpet and a Hollywood guest. The more modern look of the space meant that new arrangements tailored to the needs of groups using the facility needed to be utilized, such as intimate cabaret-style seating at tables. The balcony area changed as well. For those paying the premium ticket price, they gain access to large home theater seats, a VIP lounge, and one of the few things at the World that did not change during the restoration—the best view in the house. (Above, courtesy of Robert Hanna; at left, Lahaina Architects, Philip Cudaback-partner.)

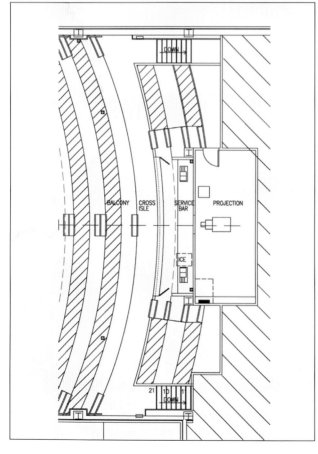

BIBLIOGRAPHY

Heffernan, Kevin. *Ghouls, Gimmicks, and Gold: Horror Films and the American Movie Business 1953–1968*. Durham, NC: Duke University Press, 2004.

Welling, David. *Cinema Houston: from Nickelodeon to Megaplex*. Austin, TX: University of Texas Press, 2007.

www.arcadiapublishing.com

Discover books about the town where you grew up, the cities where your friends and families live, the town where your parents met, or even that retirement spot you've been dreaming about. Our Web site provides history lovers with exclusive deals, advanced notification about new titles, e-mail alerts of author events, and much more.

MADE IN THE USA

Arcadia Publishing, the leading local history publisher in the United States, is committed to making history accessible and meaningful through publishing books that celebrate and preserve the heritage of America's people and places. Consistent with our mission to preserve history on a local level, this book was printed in South Carolina on American-made paper and manufactured entirely in the United States.

This book carries the accredited Forest Stewardship Council (FSC) label and is printed on 100 percent FSC-certified paper. Products carrying the FSC label are independently certified to assure consumers that they come from forests that are managed to meet the social, economic, and ecological needs of present and future generations.

FSC
Mixed Sources
Product group from well-managed forests and other controlled sources

Cert no. SW-COC-001530
www.fsc.org
© 1996 Forest Stewardship Council

Find Your Place in History.